IMAGES
of America

PULLMAN

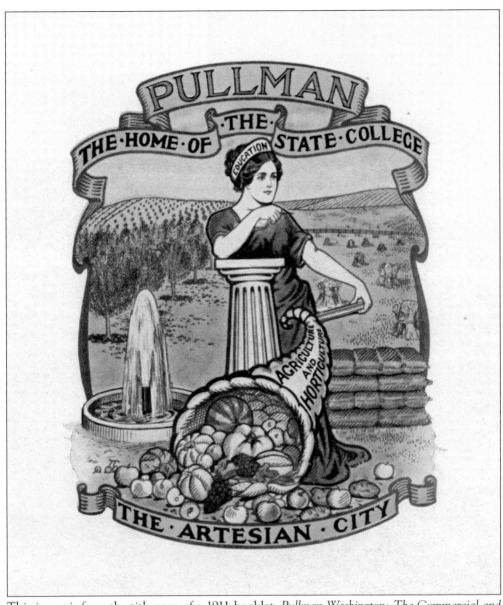

This image is from the title page of a 1911 booklet, *Pullman Washington: The Commercial and Educational Center of the Palouse Country*, published by the Pullman Chamber of Commerce, and planned, written, and executed by the Bureau of Community Publicity of the Oregon-Washington Railroad and Navigation Company.

ON THE COVER: An automobile parade on Main Street turns onto Grand Avenue on May 14, 1909. Banker James S. Klemgard had just purchased a seven-passenger Stoddard-Dayton car (front left), which brought the number of automobiles in Pullman to 15. The banner over the street announces the coming of Prof. E. K. Knapp of Chicago, "one of the most noted Sunday school workers in the United States." Knapp delivered eight addresses that Sunday, and spoke at the chapel the next morning before boarding the train to Spokane to deliver two more speeches. (Courtesy of the Whitman County Historical Society.)

IMAGES
of America

PULLMAN

Robert Luedeking
The Whitman County Historical Society

ARCADIA
PUBLISHING

Published by Arcadia Publishing
Charleston, South Carolina

Printed in the United States of America

Library of Congress Control Number: 2010921997

For all general information, please contact Arcadia Publishing:
Telephone 843-853-2070
Fax 843-853-0044
E-mail sales@arcadiapublishing.com
For customer service and orders:
Toll-Free 1-888-313-2665

Visit us on the Internet at www.arcadiapublishing.com

Robert Luedeking, 1924–2009, enjoyed
studying history and working with
people. After his retirement from
Washington State University he
switched from helping students of
Chemical Engineering to helping
people with their historical or
genealogical research. He spent most
Wednesday mornings at the archives
of the Whitman County Historical
Society. One of his projects was to
search for photographs and write
captions to be published in the
Moscow-Pullman Daily News under
the title "Picture of the Past." He
was meticulous in getting the facts
correct. Sometimes this meant that
he returned to the archives or went to
the Holland Library at Washington
State University to verify them.
He prized his friendship with the
other volunteers at the archives.

—*Leila Luedeking*

CONTENTS

ACKNOWLEDGMENTS

The Whitman County Historical Society produced this volume based upon the work of the late Robert Luedeking. In this endeavor, the historical society has enjoyed the enthusiastic support and encouragement of many organizations: Pullman Chamber of Commerce, City of Pullman and Neill Public Library, Whitman County Genealogical Society, Pullman Regional Hospital, and Washington State University (Manuscripts, Archives, and Special Collections, University Libraries, and University Relations). The book contains the images and captions written over the last decade by Luedeking and printed as "Pictures of the Past" in the *Moscow-Pullman Daily News*. Although Pullman lost a dedicated historian when Bob passed away in 2009, this book presents many of his carefully researched captions and images chosen from the collection of the Whitman County Historical Society. Some omissions and additions were necessary in order to tell the story of Pullman's rich heritage.

Edwin Garretson, editor of the historical society's journal, *Bunchgrass Historian*, assumed the position of the book's editor and selected three colleagues to support and advise him on all matters concerning the book and the story it tells about Pullman. The three, Robert E. King, Monica Bartlett Peters, and Timothy J. Marsh, have long been interested in Pullman's history and each has done research and written about aspects of Pullman history. They responded to my every request with an expertise, devotion, and speed that truly amazed me. I am grateful to them.

Many, many others used their skills to ensure the completion of this project. Steven M. Watson scanned all the images for publication, and Kathryn E. Meyer retyped many newspaper captions and proofread text. Numerous individuals contributed, in ways they may not even be aware of, to this volume: Mary Jane Engh, Tammy Lewis, Mary MacDonald, Megan Guido, Robert Hubner, Mark O'English, Trevor Bond, Robert Smawley, Judy McMurray, Stanley Buckley, Christine and Terry Gray, and Leila Luedeking.

Special thanks go to all who donated photographs to the Whitman County Historical Society. In addition to these photographs, we thank WSU Manuscripts, Archives, and Special Collections for permission to reproduce three photographs used on pages 96, 99, and 122, and Robert Hubner of WSU Photograph Services for the photograph on page 127.

—*Edwin P. Garretson Jr.*

INTRODUCTION

Pullman, best known today as the home of Washington State University, is located in the heart of the rich agricultural Palouse Country of eastern Washington State. Named for George Pullman, the 19th-century railroad car manufacturer, the city was established among picturesque rolling hills where three rivers and creeks join. Prior to the arrival of the first non-native settlers in the region in the late 1860s and early 1870s, what would become downtown Pullman was an important stopping place for Native Americans. Lush grass covering the future center of the city provided feed for Native American horses. The same tall grass drew early cattlemen and sheepherders, whose presence initially discouraged homesteaders from claiming land.

Although prospective settlers had visited the Pullman area for years, Bowlin and Sarah Farr and their young family were the first to take up permanent residence in 1874, locating near basalt bluffs in the vicinity of today's Park Street at the edge of Military Hill. Sarah Farr's uncle, Lewis Ringer, later a Pullman resident, had settled by 1871 on the Snake River southwest of Pullman. Thus the Farrs, like many Pullman settlers to come, had relatives or friends already in the region, which was fast gaining a national reputation for its highly productive farmland and good climate.

In the mid-1870s, more families began settling at "Three Forks," as the Pullman area was first termed. (The name referred to Dry Creek, Missouri Flat Creek, and the South Fork of the Palouse River, which join in what is now the downtown area.) The newcomers included the Leonard Crawford family, Thomas H. Kayler, Peter Graham, the John Glaspey family, the Samuel Rossiter family, and the Daniel McKenzie family. McKenzie was later affectionately called "Uncle Dan" for his longtime role in promoting the town's development. His wife Sarah was instrumental in establishing the town's first Methodist church building. The McKenzies were the first of the early Pullman pioneers to build a residence in what became the core downtown business area.

In 1881, no doubt encouraged by the increasing development of railroads in the region, Farr, in cooperation with McKenzie and other early settlers, platted a town. Within a year it was modified and expanded; the current streets in central downtown Pullman were established at that time. The original town of Pullman was laid out from parts of Farr's and McKenzie's homesteads that met at approximately Grand Avenue. Both later sold lots to Orville Stewart, who had been contacted with the goal of starting a town. In mid-1881, Stewart arrived from Oregon and soon built a residence and small store. Included in the store was a post office, with the name "Pullman"—selected in hopes of enticing railroad-car-manufacturer George Pullman to aid the new settlement. While nothing significant came from this, the name stuck. The new town grew steadily as more people and businesses arrived. By 1882, Pullman had its first of several churches, and by 1883, its first hotel.

In the early 1880s, the Edward Laney family arrived by wagon, including 16-year-old daughter Lula. She became Pullman's first schoolteacher and in 1887 married Pullman pioneer real-estate dealer and insurance man Eugene W. Downen, who had arrived in 1884. Lula Downen's writings preserved much of Pullman's early history. Longtime resident Thomas Neill, who arrived in 1888,

also wrote an important history of the town. He established the first newspaper, the *Pullman Herald*, which was published for exactly a century. Later Pullman historians, including Esther Pond Smith and Robert Luedeking, have used the *Pullman Herald* as an important source for their writings about the town's history.

In 1885, to the delight of Pullman residents, the first of two railroads was built through the town, adding greatly to the town's commercial ambitions. In 1889, while workers were drilling a well for the Palace Hotel on Main Street, the town's first artesian water was discovered. With this water source and the railroads, Pullman became known both as a transportation hub and as the "Artesian City." By the end of the 1880s, Pullman had gained a solid reputation as a prosperous commercial and agricultural center. This and the plentiful supply of artesian water were key factors in Pullman's becoming an educational center.

In 1891, the same year that Pullman was selected by the state's legislature to receive the new land-grant college, plans were already under way to build a military college for young men. It became Pullman's first institution providing education beyond the 8th grade level, which was uncommon for towns of Pullman's size at that time. The new military school opened on what became known as Military Hill in late 1891, while in January 1892 the new agricultural college started classes on the hill to the east, now called College Hill. For over a year, Pullman proudly claimed two colleges until fire—a plague of early Pullman—burned the military college to the ground. It was never rebuilt. Like its short-lived rival, the agricultural college initially offered high school–level classes. This preparatory-school function continued at the college for several years. It enabled students from nearby towns without high schools to have an opportunity to succeed in subsequent college-level work.

From its first classes held in 1892, the small agricultural college on the hill grew into Washington State University. Today WSU is a highly respected, world-renowned academic and research institution. Its attendees and graduates from all corners of the globe will soon number more than a million. Throughout Pullman's vibrant history, the initial seeds for its future success—commerce, agriculture, community spirit, and education—continued to grow and shape the town's destiny. More recent have been the addition of high-tech manufacturing, serving 21st-century industrial needs, and a nationally known annual Lentil Festival. The festival brings attention to another equally important local crop in a region already world famous for wheat, barley, and peas.

This book explores Pullman's exciting history in nine chapters covering the city's beginnings, its commerce, its main street, its educational facilities, and its homes and churches. Certain events that challenged and changed the town are shown in old photographs. These include fires, floods, and other catastrophes—all overcome by a town destined for greatness. The book concludes with a look at the special celebrations and the everyday events that make Pullman unique. This pictorial tour shows how Pullman changed from a late-19th century commerce center in a rich, fast-developing agricultural region into a 21st-century city that today is among the most vibrant, productive, and renowned in the Pacific Northwest.

—*Robert E. King*

One

PULLMAN AT
THE BEGINNING

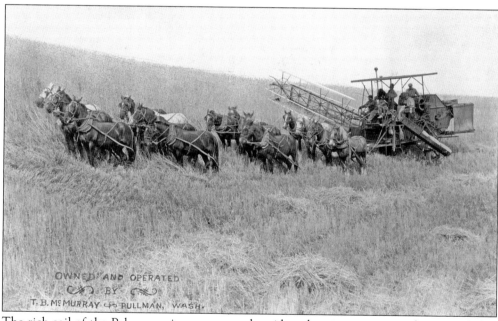

OWNED AND OPERATED
BY
T. B. MᶜMURRAY PULLMAN, WASH.

The rich soil of the Palouse region encouraged rapid settlement once it was determined that wheat would grow here. Early farming was labor intensive and required the nearby goods and services of a town for support. Pullman emerged in the early 1880s as a support town. Its access to water, transportation, and education soon led to rapid development. As shown in this 1928 photograph of T. B McMurray farms, wheat harvest near Pullman required many horses and men. These early combines were not self-leveling and required manual control. The McMurray family still farms this land.

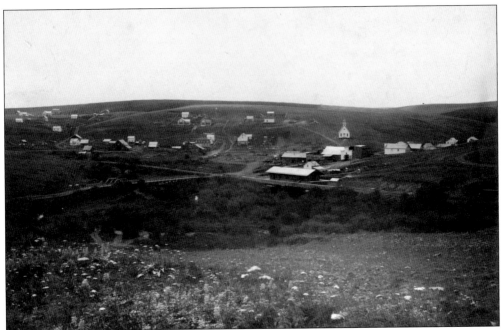

This photograph shows Pullman immediately after the disastrous fire of June 26, 1887. It was taken from Military Hill, looking southeast toward Pioneer Hill. The Oregon Railroad and Navigation Company depot and the swamp where Pullman's three streams join are in the foreground. Grand Avenue runs across the photograph. The church at center right is the original Congregational church on the southeast corner of Paradise and High Streets. It survived the 1887 fire, but was destroyed in the 1890 fire.

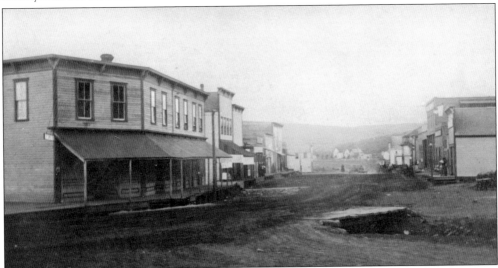

This photograph of Main Street (around 1888), looking east from Grand Avenue, shows buildings that stood for only three years. This "second" Pullman, built after the 1887 fire, was destroyed by fire in 1890. The structure in the left foreground was the Nodine Building, housing a meat market and saloon. The McConnell and Chambers department store, operated by two Moscow merchants, was in the two-story brick building on the right. The bridge in the foreground provided access over Dry Creek.

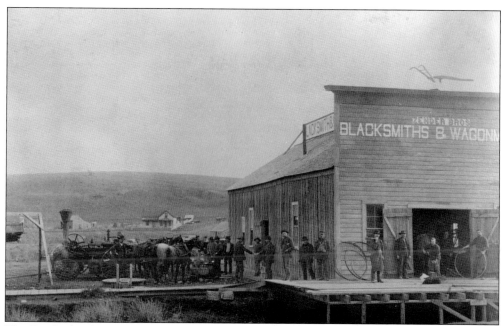

The Zender brothers, Martin and A. J., were blacksmiths and wagon makers who operated one of Pullman's earliest enterprises. This shop at the corner of Grand Avenue and Olsen Street was established in 1883, when Pullman was a village of about 35 people. In 1908, the remains of the wood-frame building were removed to make way for the Bloomfield Block, a two-story brick structure. After it was destroyed by fire in 1992, the Cougar Plaza was established on the site.

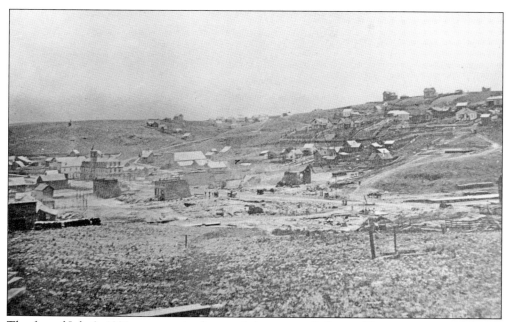

The fire of July 3, 1890, once again destroyed downtown Pullman. The intersection of Grand Avenue and Main Street is at right. The large structure with the tower at left was the Palace Hotel, on Main Street where the Audian movie theater stands today.

Pullman's first bank and first city hall were housed in this small wooden building at 251 East Main Street. The Bank of Pullman opened here in July 1887. This structure survived the 1890 fire only because it had been moved in preparation for a new brick bank building. The Bank became the First National Bank of Pullman in 1892. This 1928 photograph shows the little building at 420 Main Street, finishing its days as the Sunrise Barber Shop.

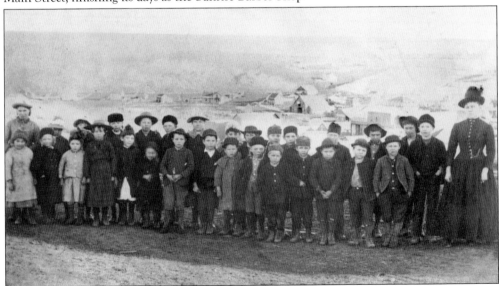

Lula Laney (far right) posed with her pupils in 1887–1888 for this picture taken by Lachlan Taylor, Pullman's first photographer. Laney was Pullman's first schoolteacher, but she resigned when she married Eugene Downen. The photograph appears to have been taken from a site just east of the present day Gladish Community Center on West Main Street.

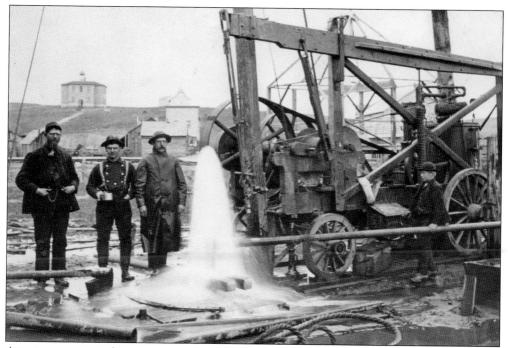

Artesian water was first encountered in May 1889. The artesian well shown here was struck in 1889 or 1890. This one was located in what is now the parking lot east of Neill Public Library. The plentiful water supply from these wells was a stimulus to Pullman's early growth. The building in the distance in the upper left was the second schoolhouse in Pullman, located on the present site of the Gladish Community Center.

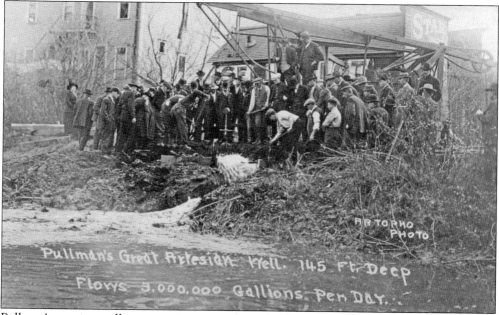

Pullman's artesian wells were an important factor in the selection of the town as the location for the Washington Agriculture College and School of Science. This well appears to have been located west of North Grand Avenue. The photograph was probably taken about 1913.

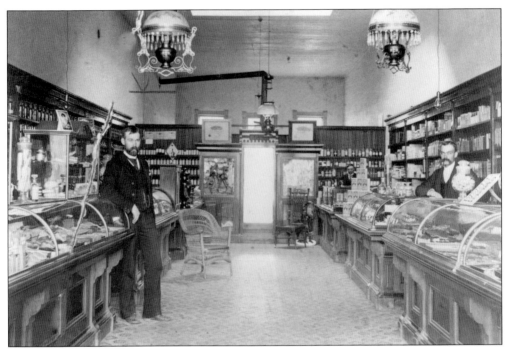

White Drug Store, in business continuously from 1883 to 1998 in at least five locations, is pictured about 1893 at 227 East Main Street. The space is now occupied by Saunders Interiors. Pictured are Dr. William L. White, left; brother Archie White, at the rear of the store; and brother Dr. Charles White, at the right.

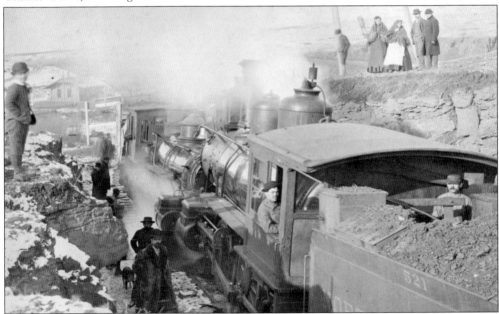

A train "wreck" resulted when two Northern Pacific locomotives confronted each other in the cut east of Kamiaken Street (near the present-day location of the Spot Shop) about 1892. The wooden building at left was the Oregon Railroad and Navigation Company depot (later the Union Pacific), the site of today's Cougar Depot. Both railroads played an important role in Pullman's early development.

Two

At Work

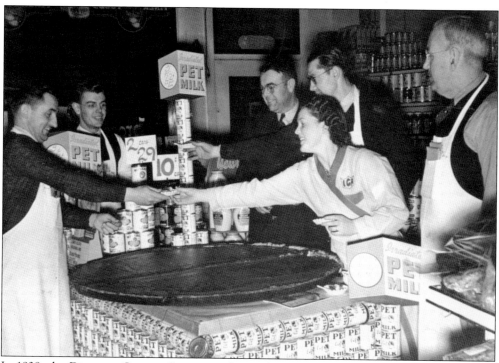

In 1938, the Dissmore Grocery Store served pumpkin pie as part of a promotion for Pet Milk. Shown here are Chester Dissmore (second from the left), Gertrude Brown Dissmore (fourth from the left), and Guy Dissmore (far right). Guy and Chester Dissmore had purchased the small IGA store at 207 East Main Street only a year earlier. Their move to a spacious building at 300 South Grand Avenue in 1941 created Pullman's first supermarket. In 1956, Dissmore's IGA moved to its present location on North Grand Avenue.

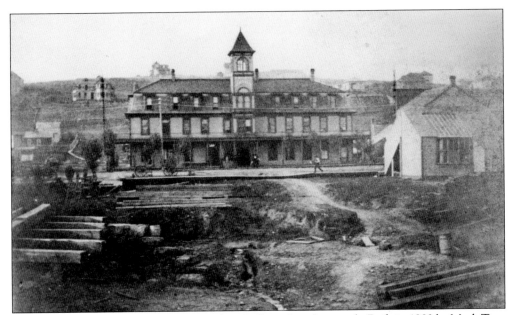

The Palace Hotel played an important role in Pullman's early growth. Built in 1883 by Mark True when Pullman's total population was less than 50, it was originally located on Paradise Street by Kamiaken Street, on the present-day location of Pullman City Hall. It was moved on log rollers in 1889 to the southwest corner of Main and Pine Streets where it was when this picture was taken. That is now the site of Basilio's Restaurant. The hotel was destroyed by fire in 1909.

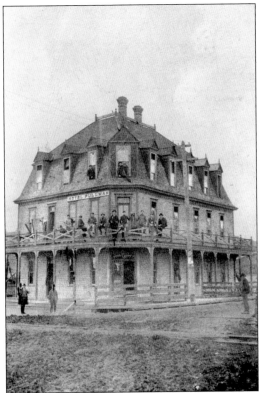

The Hotel Pullman was built in 1893 across the tracks from the Oregon Railroad and Navigation Company depot, now the Cougar Depot. Originally named the Union Hotel, it was called Hotel Pullman from 1894 to 1898, and then the Alton Hotel until 1918, when it was demolished to make way for a lumberyard. The hotel housed 65 students after the men's dormitory on campus burned in 1897. Its history also includes a murder/suicide in 1906.

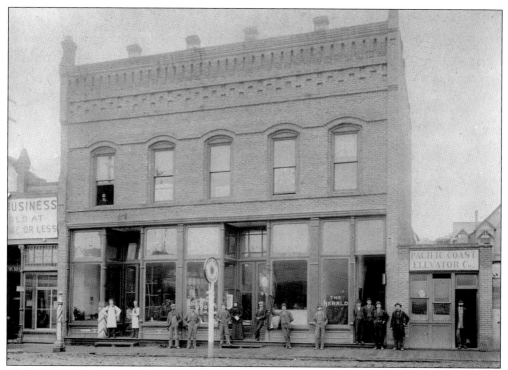

The Webb Block in 1896 housed a men's clothing store and the *Pullman Herald*. The building at 215 East Main Street was erected in 1891 by Dr. Henry J. Webb. Home in the past to such enterprises as the City Club and the Combine Mall, the building was remodeled in 2005. The three men standing in the entrance to the *Pullman Herald* (the last doorway on the right) are Wilford Allen, Ira Allen, and Thomas Neill.

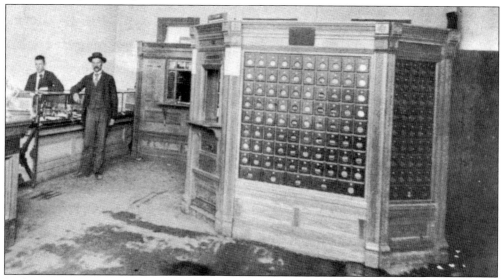

In the 1890s, the Pullman post office was located in a building on East Main Street. The man wearing a hat is John T. Lobaugh, appointed postmaster in 1889. Lobaugh owned the 138 lock boxes shown here. In addition to the stationery store he ran in the post office, he also rented space for a telegraph office, a jeweler's bench, and a cigar shop and newsstand.

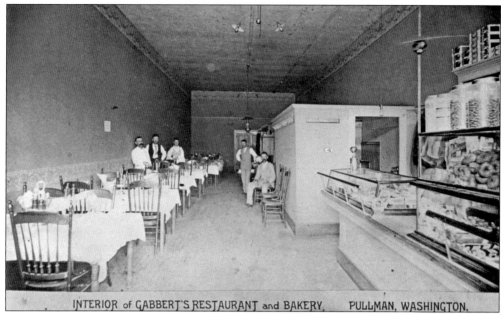

INTERIOR of GABBERT'S RESTAURANT and BAKERY. PULLMAN, WASHINGTON.

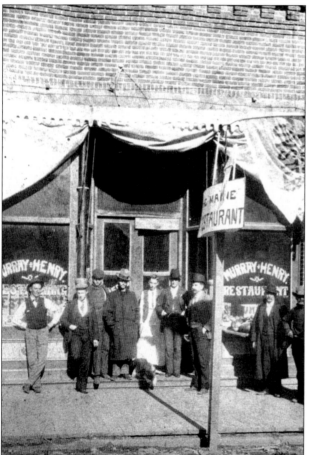

Gabbert's Restaurant and Bakery was located at 226 East Main Street in downtown Pullman in the early 1890s. The site later housed Murray Henry's Bakery and Restaurant. Later still, it was home to the Oriental Café and numerous other businesses. In 2010, the Licks ice cream shop operates in this small brick building on the north side of Main Street.

Murray Henry, standing in the entrance next to the post, constructed this building at 226 East Main Street in 1890 and 1891, and later added a second story to it. From the mid-1890s through the first decade of the 20th century, Henry ran a restaurant in this building, which still stands today. This photograph was probably taken around 1900.

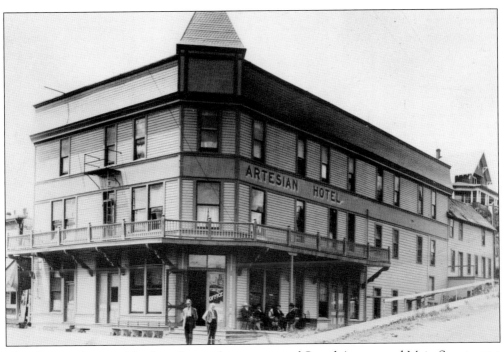

The 42-room Artesian Hotel on the southwest corner of Grand Avenue and Main Street was a prominent business from its opening in 1893 until it was destroyed by fire in 1922. It was initially operated by Joshua M. Palmerton, whose home, still standing, can be seen behind. The Artesian Hotel fire, on September 3, 1922, was one of Pullman's hottest and most spectacular blazes. It lit up the night sky with a red glow that was seen from Colfax and Genesee. The heat from the fire was so intense that it shattered all of the windows in the brick Flatiron Building and set the wooden window frames on fire. In 1923, a Chevrolet dealer built on the site. After Chipman and Brown moved the dealership to Bishop Boulevard in 1986, the building was remodeled several times and now has businesses on the ground floor and apartments above.

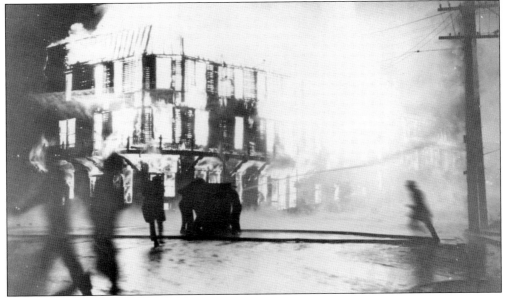

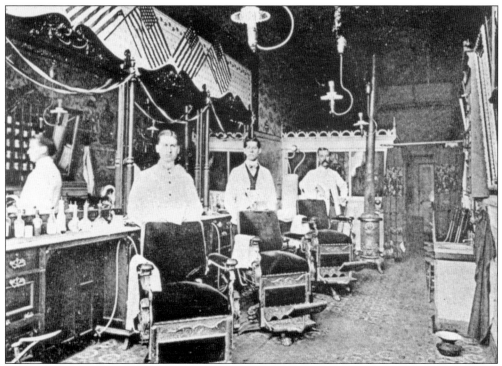

The WAC Baths and Barber Shop, which took its name from the Washington Agricultural College, advertised itself in 1903 as the "Oldest and Best Establishment in the City." William H. Engelert was the proprietor. At that time a rented room seldom included bathing facilities, so workingmen and other renters went to the barbershop for their weekly or monthly baths.

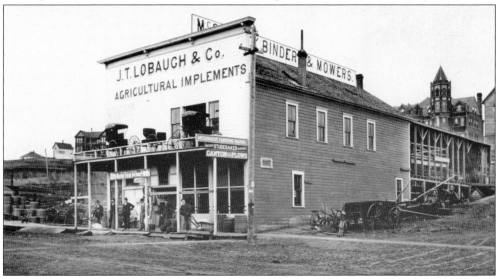

The J. T. Lobaugh and Company Farm Implements Agency is shown about 1900, at 141–151 North Grand Avenue. Pullman's 1892 school is seen behind, to the right, and Dr. H. J. Webb's stately home is immediately to the left of the store. Lobaugh operated the business from 1896 to 1904, when he sold it to A. B. Baker. T. C. Martin acquired it in 1911 and remained at that location until 1930, with the second floor serving as living quarters for him and his family.

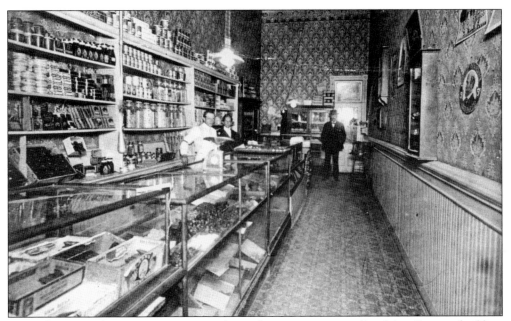

Around 1900, a tobacco store was squeezed into the narrow space on East Main Street, a building alongside the old Corner Drug. Before the tobacco store, the space housed an insurance office. Later it served as the Zalesky Tailor Shop, Britton's Shoe Store, and Gertrude's Beauty Salon. For many years, it was optometrist Robert DeVleming's office.

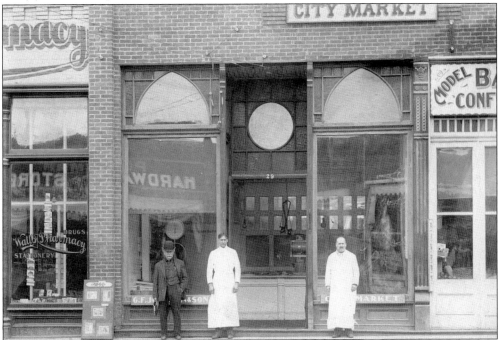

Standing in front of the City Meat Market about 1907 are policeman Fred Gelwick (left), meat-cutter Ralph Johnson (center), and owner-proprietor George F. Johnson (right). Watts Pharmacy was to the left of the store and the Model Bakery was to the right. The market was located in a building at 243 East Main Street.

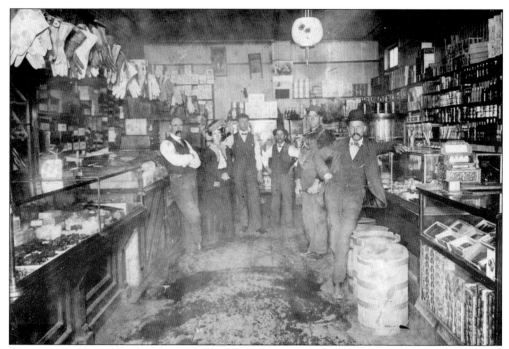

The interior of Fariss Brothers hardware and general merchandise store at 231 East Main Street is seen here around 1905. It served the town for more than 20 years. On the right is Alvin T. Fariss, and on the left is his brother Frank. Alvin Fariss came to Pullman about 1882, was elected to the territorial senate in 1888, and helped secure the state agricultural school for Pullman.

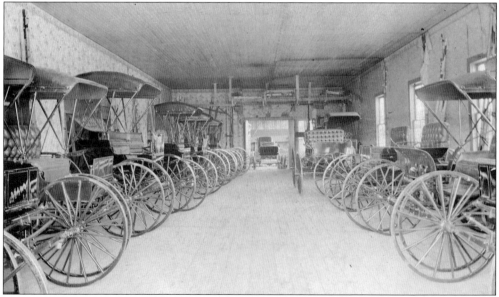

In 1904, the A. B. Baker Company, which sold farm machinery and vehicles, displayed this collection of buggies in its Grand Avenue store just north of the former Cordova Theater. After reading that a college was to be located in the town, Albertus B. Baker moved his family to Pullman in July 1891. He operated the implement store until 1911, when he sold it to T. C. Martin. Baker and his wife Mary lived in the same Spaulding Street house from 1892 until their deaths in 1946.

In 1908, the Downen Realty Company moved into its new building at 222 Main Street. Eugene Downen, Pullman's second postmaster (1885 to 1889), founded the business in 1886. Since then, four generations of Downens have been associated with the business. In the mid-1980s, it combined with Sayles Insurance to form Associated Independent Agencies and moved to South Grand Avenue. The man on the left is Dan Downen. The one in the center is E. W. Downen.

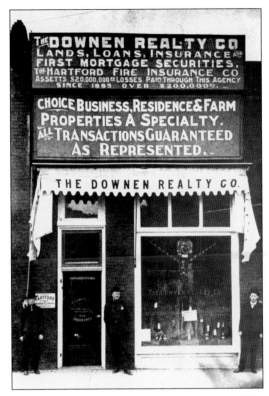

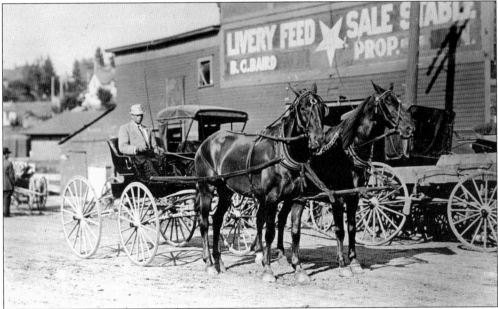

The Star Livery Barn was located on North Grand Avenue next to the Palouse River where the Neill Public Library parking lot is now located. Built in 1891, it was operated until 1901 by W. S. Reider. Hay was stored in the loft; the livery would "hire out" carts, buggies, teams, and even drivers, if desired. Over 25 different proprietors operated the business between 1901 and 1915, when it became the Potlatch Lumber Company lumberyard. The building was torn down in 1938.

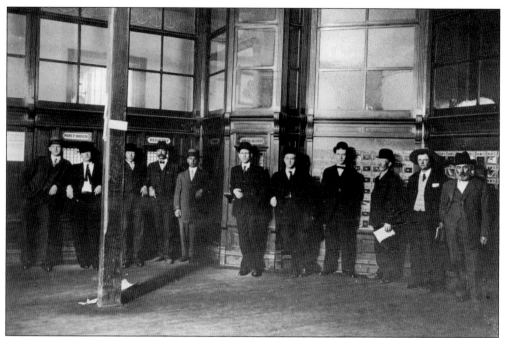

In 1909, letter carriers and clerks pose in the lobby of the Pullman post office at 135 Kamiaken Street. At the far right is postmaster K. P. Allen, who served in the Union Army all four years of the Civil War. From left to right, the other postal workers are Will Waller, R. M. Van Doren, Clarke Nye, W. H. Latta, A. R. Moore, H. W. Sampson, Ira Allen, Verne Foster, W. H. Tapp, and Cliff Parr.

The Gray Horse Importing Company of Pullman had its stables on the south side of Main Street between Pine and Paradise Streets from 1901 to 1915. Its proprietor, Milton C. Gray, was well known throughout the region for his fine horses, particularly his Belgians, Percherons, and Shires. In 1907 Gray served as Pullman's mayor. This photograph was taken in 1910.

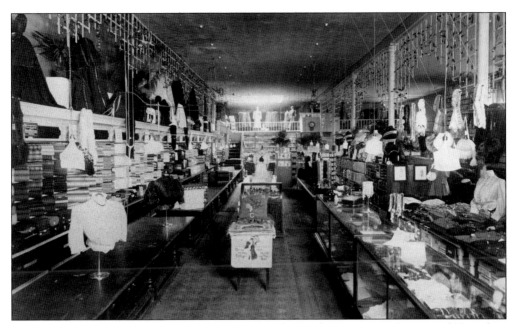

The Burgan-Emerson Mercantile Company was on the northwest corner of Main and Kamiaken Streets when this c. 1909 photograph was taken. The display in the center, directed to the college crowd, has a pillow decorated with the letters WSC. The poster below it reads: "Here's to the College that stands on the Hill." The store became the Emerson Mercantile Company in 1912 when E. S. Burgan moved to Spokane. In 1916, after the building was destroyed by fire, J. N. Emerson moved the store to the southeast corner of the same intersection. Emerson's son Robert later started the Empire Department Store where U.S. Bank now stands. In the photograph below, the Burgan-Emerson Mercantile assembles its employees and delivery cart for the photographer in 1908.

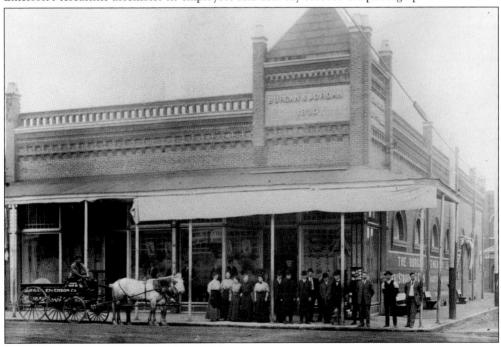

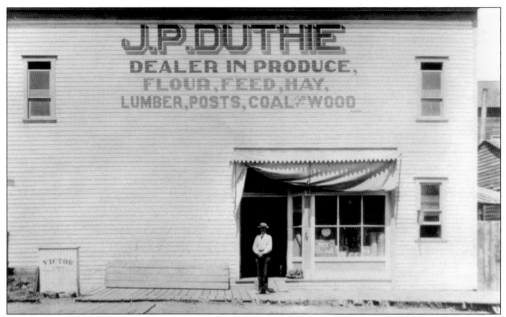

Early Pullman merchant John Purvis Duthie poses before his store on South Grand Avenue. He later moved the business to the southwest corner of Grand Avenue and Whitman Street, now a parking lot. Duthie, who came to Pullman in 1905, was active in a variety of community organizations, served 20 years on the city council and 6 years as mayor. He sold his business in 1945 to his son, Roscoe Duthie, who operated it until it closed in 1965.

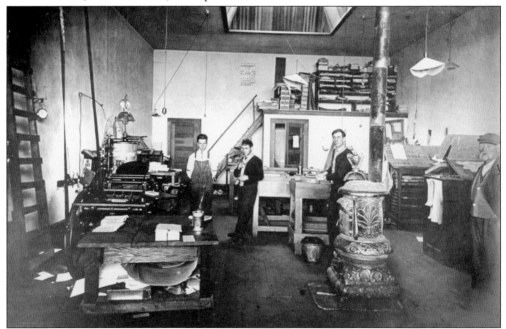

The Pullman *Tribune* print shop was a busy place when this photograph was taken about 1911. The *Tribune*, a weekly newspaper, competed with the *Pullman Herald* from 1893 to 1919. The shop was located on Paradise Street. The two men standing at left are identified as Mark Morgan and Lee Wenham, but editor/owner Lou Wenham does not appear in this picture.

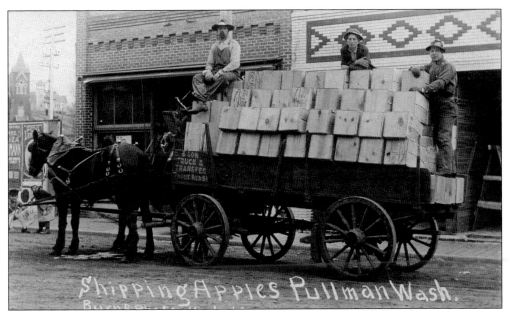

Boxes of apples are loaded and ready to ship in this 1910 picture, taken on the 100 block of North Grand Avenue. At the time, a substantial orchard industry appeared to be developing in the Pullman area. Local farms produced apples, pears, peaches, nectarines, and apricots, as well as grapes, melons, and berries of all kinds. One 22-acre orchard adjoining the city shipped 7,000 boxes of apples that year.

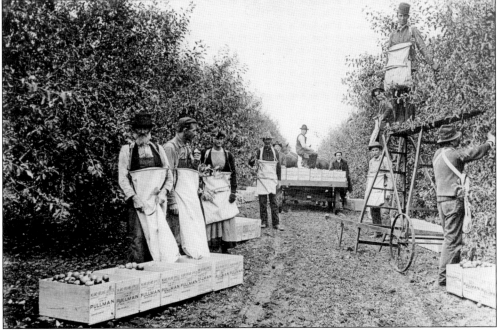

An apple-picking crew works in an orchard just west of Pullman about 1910. The Pullman Chamber of Commerce tried promoting the town as a fruit-growing center, but other areas of the state soon became more famed than the Palouse for their orchards. Nevertheless, over 11,000 boxes of apples and other fruits such as pears and cherries were shipped from Pullman in 1910.

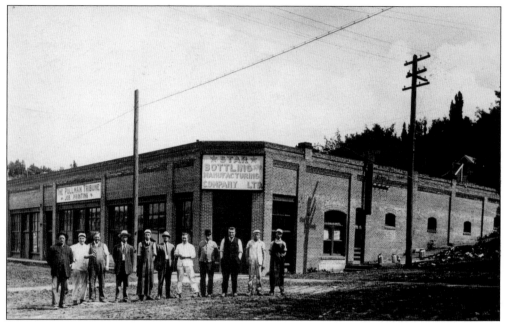

The Star Bottling and Manufacturing Company was located in Pullman on the southeast corner of Kamiaken and Paradise Streets about 1911. It started in 1891 as the Star Bottling Works on Pullman's Main Street. After three moves and several changes in name and ownership, the enterprise ended in the 1950s as the Cougar Beverage Company on South Grand Avenue, where Sim's Glass is now located.

Thomas C. Martin demonstrated this early automobile to four men in front of his implement store on Pullman's Grand Avenue just south of Olsen. One of the first in town to sell automobiles, Martin carried a large stock of this exciting new invention.

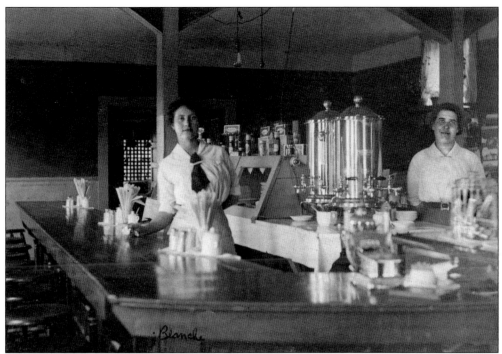

The Northern Pacific Railroad depot featured a lunch counter in August 1912. The woman on the left is Blanche Rambo Crawford (1891–1966); on the right is the manager, a Swedish woman sent out from Wisconsin. Crawford went on to manage Northern Pacific Railroad lunch counters in the Mandan, North Dakota; Pasco, Washington; and Missoula, Montana stations. The railroad later replaced this depot with the structure now known as the Pufferbelly Depot.

Charles Zalesky stands in his brother's tailor shop about 1918. Frank Zalesky came to Pullman in 1903, and in 1905 he erected a small brick building on Kamiaken Street, next to the present Moose Lodge. In 1921, after taking over the business, Charles moved the shop to 239 East Main Street, where he continued business until the mid-1930s, when he moved the tailor shop back to the original site on Kamiaken. The business closed in the late 1930s.

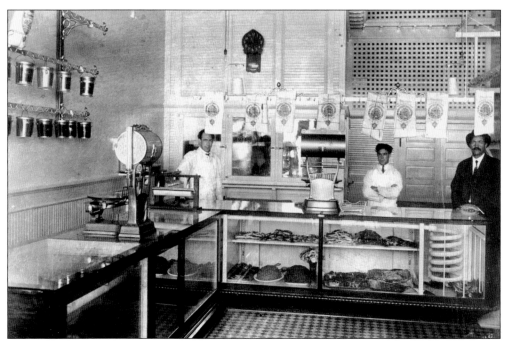

Seen here around 1918, the City Market was located at 243 East Main Street. The meat market was owned by Ralph C. Hamilton (left) and Arle W. Shellady (not pictured). During the 1920s, the business operated a slaughterhouse on North Grand Avenue. City Market closed in 1942.

Roy Neill and his daughter Marian stand behind the counter of Neill's Sweet Shop in the mid-1920s. Now called Neill's Flowers and Gifts, the shop has been in business since 1920 at 234 East Main Street. While still a student, Neill began his career as a florist in 1909 with his own greenhouse. In 1920, with his purchase of the Oasis Confectionery, Neill's Sweet Shop was born, complete with soda fountain, confections, and gifts, in addition to the flowers.

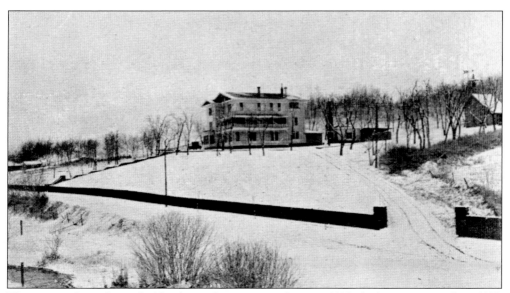

The picture above shows the Northwest Sanitarium in January 1919; the lower image is from 1917. This building, located at 905 South Grand Avenue, was originally built in the 1890s by Lewis Ringer as a home for his family. Dr. Matthew J. Beistel purchased it in 1916 to establish a hospital, which he operated until 1923. It boasted a complete hydrotherapy outfit, a bake oven, an electric light cabinet bath, and 33 beds. In addition to Dr. Beistel, four other Pullman physicians were on staff, as well as a "skilled dietician." An advertisement described the Sanitarium as "beautifully surrounded by 11 acres of wood, orchard, and shrubbery." The building served as a private home from 1923 until 1931, when Kimball and Son moved its funeral establishment there, with the business continuing to this day.

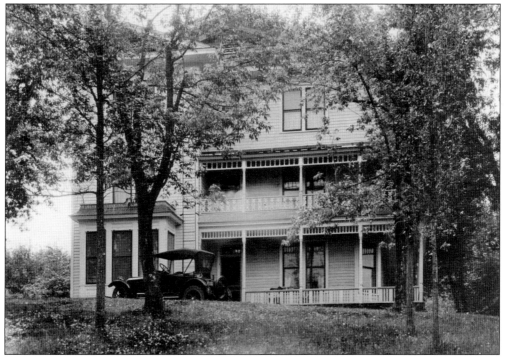

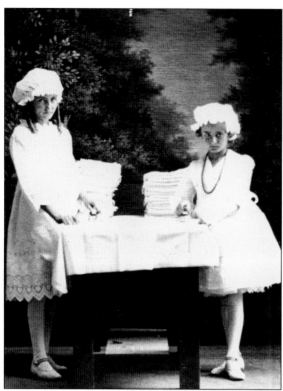

In 1920, barber Ed Tower advertised, "A clean towel per customer!" on a slide projected on Pullman movie screens between films. The girls ironing the towels are his daughters Veta (left) and Hattie. Daniel Edson Tower (1879–1961) barbered in Albion and Colfax before coming to Pullman in 1903. He operated two different barbershops in town, the first on Kamiaken Street from 1915 to 1939, and the second in the Audian Theater building from 1939 to 1959.

The Bloomfield Block, pictured in the 1920s, was built in 1908 and 1909 on the site of the Zender blacksmith shop at the corner of Grand Avenue and Olsen Street. It was destroyed by fire in 1992 and replaced by the Cougar Plaza. The Pullman Hotel (originally named the New Palace Hotel) occupied the upper story from 1909 to 1978. The ground floor saw many businesses over the years, including an American Express office, the Greyhound Bus depot, the Nica Art Gallery, various cafés, and JC Penney.

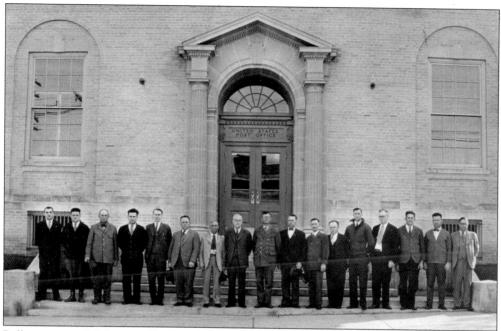

Pullman opened this post office on the southwest corner of Paradise and Kamiaken Streets in 1931. Posing for its opening were its 17 employees, including postmaster Ira G. Allen, eighth from the right. This building served as Pullman's post office from 1931 until a new post office was opened on South Grand Avenue. Since 1976, the old yellow-brick building has housed a movie theater and a variety of businesses.

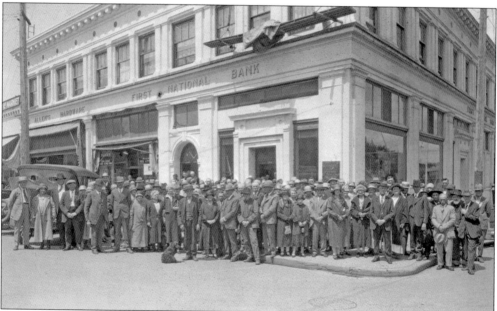

The First National Bank of Pullman, on the northwest corner of Main and Kamiaken Streets, marked the 40th anniversary of its founding with a lavish celebration on June 11, 1927. The daylong open house featured scores of photographs from Pullman's early days. About 250 pioneers who had been in or near Pullman in 1887 came and were treated to a luncheon and program at the White Owl.

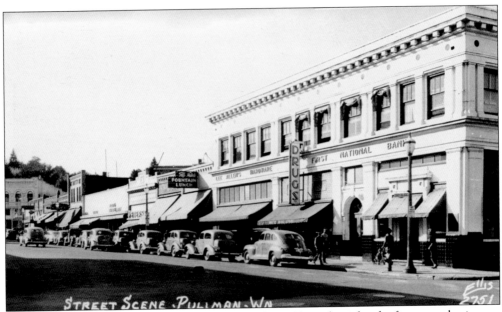

In 1942, Main Street was active with businesses and cars. From the right, the first seven businesses are the First National Bank of Pullman, White Drug Store, Lee Allen Hardware, the Top Notch Café, Glover's Hardware, Peterson's Grocery, and Neill's Flower Shop.

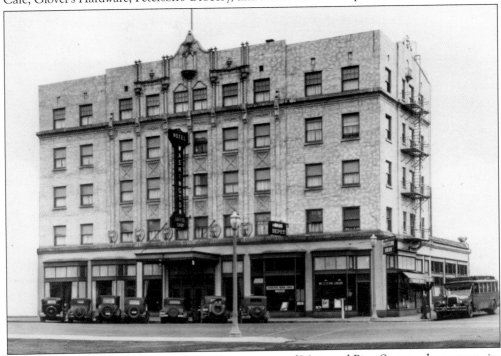

The Washington Hotel stood on the southeast corner of Main and Pine Streets, the present site of Bank of America. Constructed in 1927, it was just one example of civic improvement achieved by Pullmanites working cooperatively. Realizing the town's need for a first-class hotel, 394 people subscribed a combined $131,800 to begin construction. In addition to its 60 guest rooms, the hotel also housed the bus depot, the Western Union office, a restaurant, and other businesses.

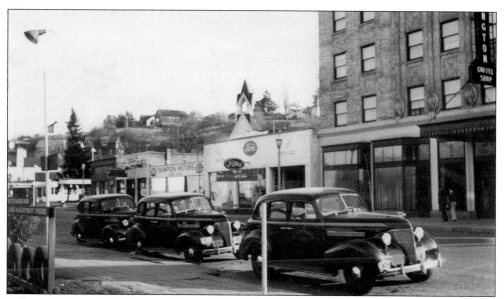

Pullman's Yellow Cab Company has parked its cabs on the north side of Main Street just east of Pine Street. The cab in the foreground of this c. 1936 image belonged to R. K. Leonard. Across Main Street was the Washington Hotel. It was built in 1927 and demolished in 1972 to make way for the Bank of America building, which is still located there.

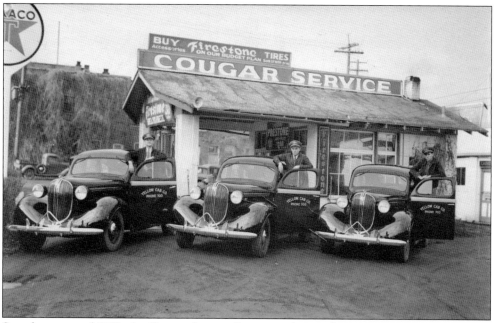

Seen here around 1939, the Cougar Service Station at the northeast corner of Main and Pine Streets featured Texaco gasoline and Firestone tires. It was removed in the early 1940s to make way for a JC Penney store, which became the home of Ken Vogel's clothing store from 1982 to 2006. The driver of the taxicab on the left is Ludie Nelson. Ernie Bailey is the driver of the cab on the right.

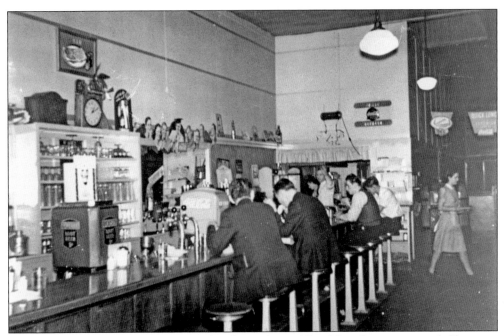

The Top Notch Café, a popular eating place located at 246 East Main Street, was nestled between Lee Allen Hardware and a variety store. Proprietor Roy Shaw bought the restaurant in 1936 and changed its name from Gentry's to Top Notch. In December 1950, Shaw sold it to Howard Hays, who changed the name to Howard's.

Dissmore's IGA Grocery was under construction in 1956 at the corner of North Grand Avenue and Stadium Way. The store has since been enlarged and remodeled several times. Guy Dissmore entered the grocery business with the purchase of a store at 207 East Main Street in 1937. He built Pullman's first supermarket in 1940 at 300 South Grand Avenue and moved it in 1956 to its present North Grand Avenue location.

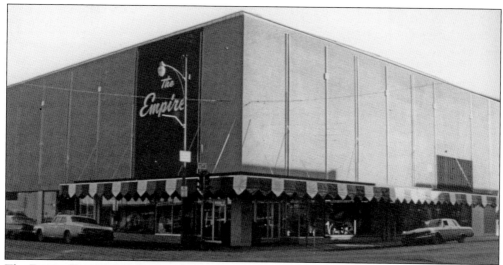

The Empire Department Store is shown here with the 1960s remodeling of the 1916–1917 brick building. Jay Noble Emerson bought into the business in the 1890s and, after the building burned in 1916, Emerson moved Emerson Mercantile to a new brick building on the southeast corner of Main and Kamiaken Streets. While the business closed in 1937, Robert Emerson reopened a store in the 1940s. From 1952 to 1982, his son Richard Emerson ran the Empire Department Store here.

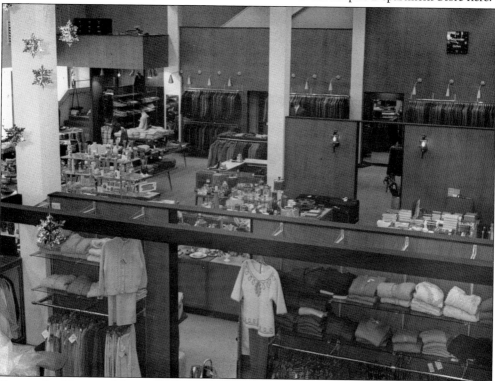

One result of the remodeling of the Empire in the 1960s was this elegant women's wear department. The store had a rich history going back to the early 1900s and involved the Burgan and Emerson families. The building that housed the store was constructed about 1916 and was demolished in 1985. U.S. Bank now occupies the space.

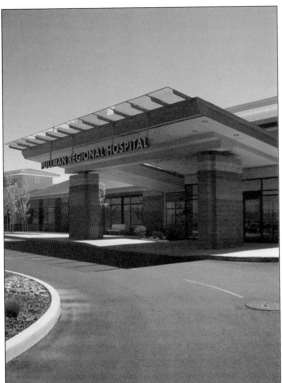

Pullman Regional Hospital opened in December 2004 on Bishop Boulevard with a dedication acknowledging the public's support of the three-year effort to build the replacement hospital. The former Pullman Memorial Hospital was housed on the Washington State University campus and served the community for more than 50 years before the new 95,000-square-foot, state-of-the-art facility was built.

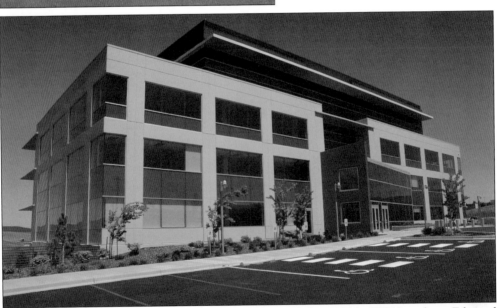

Pullman's Schweitzer Engineering Laboratories was founded in 1982 by WSU graduate Edmund O. Schweitzer III. Within two years, SEL introduced the world's first digital protective relay to the electric power industry. This new corporate headquarters building in Pullman supports a fully employee-owned company that now operates in more than 120 countries around the world. SEL products ensure the smooth operation of electric power systems and provide other digital controls.

Three

MAIN STREET
THROUGH THE YEARS

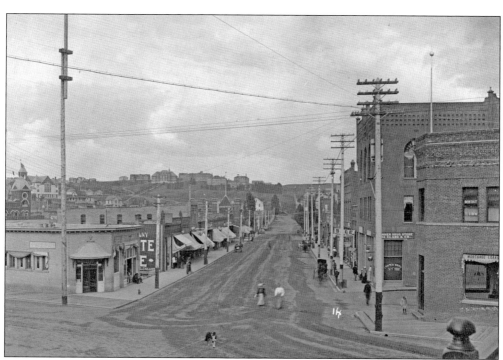

Two women and a dog cross the intersection of Main Street and Grand Avenue, unconcerned about any threat of traffic. In this 1906 photograph, the WSC campus is seen in the distance. At the time, it had fewer than a dozen buildings. The Corner Drug Store was then located in the three-story building at the corner of Main and High Streets. Dr. Low's dental office is on the second floor of the Flatiron Building at the right.

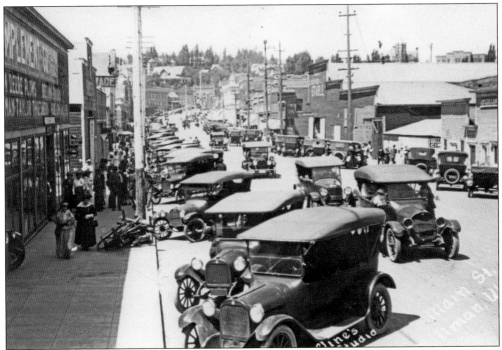

Main Street was crowded with automobiles in this c. 1919 photograph taken near the intersection of Paradise and Main Streets, looking west. Visible on the hill in the background is the Joshua M. Palmerton house (large white roof), which still stands today on the corner of Main and State Streets. Palmerton was the proprietor of the Artesian Hotel, located at the corner of Main Street and Grand Avenue, immediately below the house.

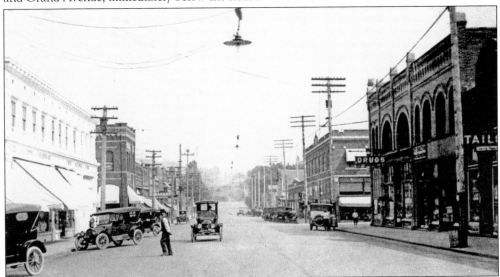

This c. 1919 Main Street view looks east toward the WSC campus. Starting at the left and going clockwise, the buildings in the foreground grouped around the intersection of Main and Alder Streets are the First National Bank of Pullman (white building), Pullman State Bank, Emerson Mercantile Company (later the Empire Department Store), and the Corner Drug Store. At night, the overhead lamps at the center of the street provided lighting.

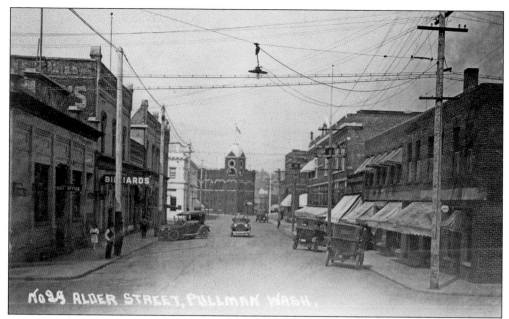

This 1920s view looks north from Paradise Street along Alder Street (renamed Kamiaken in 1929). The building at the far right was the Russell Hotel, which initially housed Dr. Russell's medical office and clinic. It is now the Moose Lodge. Next to it was Emerson Mercantile. The building straight ahead was Pullman City Hall, built right after the fire of 1890, remodeled in the 1930s, and used until 1970. The white building to its left was the First National Bank of Pullman, now Design West.

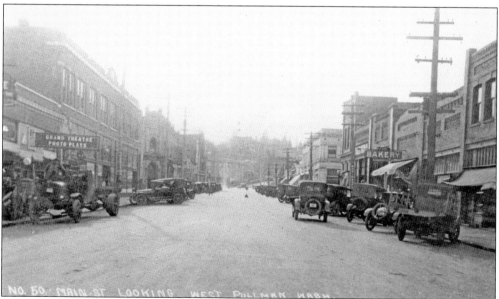

A number of prominent Pullman businesses are shown clearly in this photograph looking west on Main Street about 1920. On the left, the Grand (later the Audian) Theatre is showing "photo plays." Next is the Emerson Mercantile, later called the Empire Department Store. In the distance, at the corner of Main Street and Grand Avenue, is the Artesian Hotel. It burned in September 1922. Also visible is the center marker at the intersection of Main and Kamiaken Streets.

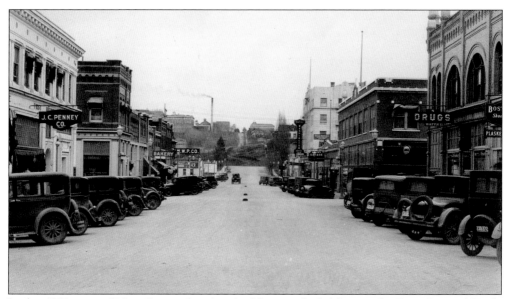

In this 1930s view of Main Street, the white building on the left houses the First National Bank, JC Penney, and Lee Allen Hardware. Though substantially remodeled, the same building is home today to Design West and other businesses. The brick building beyond was the Pullman State Bank, now remodeled as American West Bank. At the far right was the Corner Drug Store, which burned in 2000 and has been replaced with the Town Centre. Beyond were Emerson's Mercantile and the Washington Hotel.

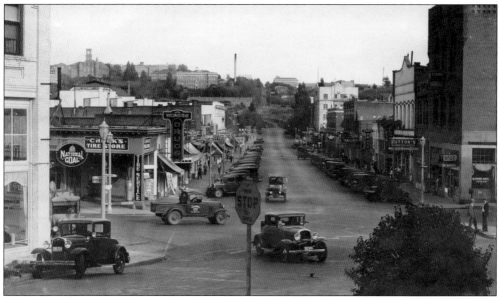

Diagonal parking was available on Main Street when this picture was taken about 1930. Businesses on the north side of the street, beyond Chuck's Tire Store, were Meiners Drug Store, the Smoke House, the Oriental Café, Neill's Candy and Flowers, and Burgan's Grocery. On the south side of Main were the Nook Grill, Dutton's Candies, the City Club, and White Drug Store. The white building two blocks farther east was the Washington Hotel.

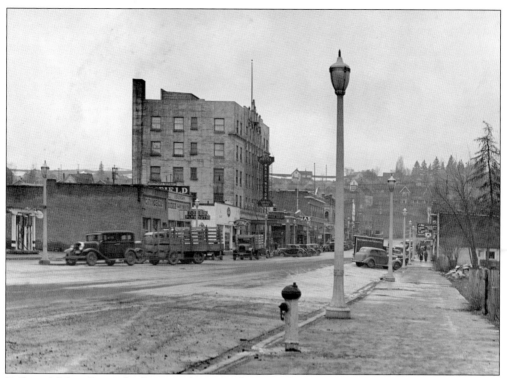

Pullman's Main Street (looking west) is partially covered with snow in this picture, which appears to be from the 1930s. The five-story building in the center was the Washington Hotel. Built in 1927, it was for many years an important part of Pullman life and activity, but it was demolished in 1972 to make way for the Seattle First Bank, now Bank of America.

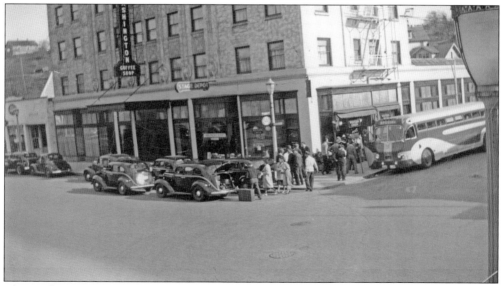

The Washington Hotel, which stood until 1972 at the southeast corner of Main and Pine Streets, is shown here in 1938. It not only provided accommodations for travelers, but also housed the bus depot and Western Union (telegraph) office as well as a coffee shop, dining room, and meeting rooms for local organizations.

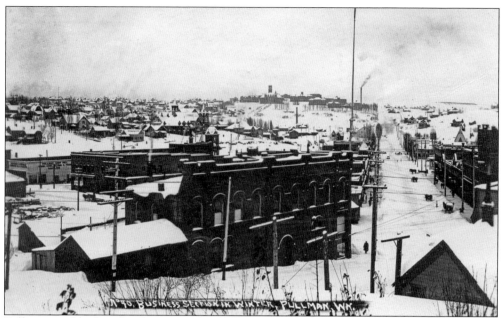

Pullman was blanketed with snow in this 1912 picture, which was taken from West Main Street, looking east over downtown toward the campus of Washington State College.

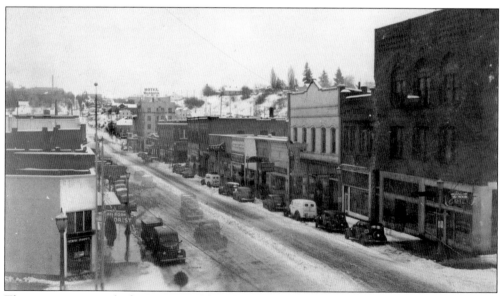

This winter picture, looking east on Main Street, was taken about 1935 from a second-story apartment on the northwest corner of Main Street and Grand Avenue. The tall building left of center was the Washington Hotel, located at the southeast corner of Main and Pine Streets at the present site of Bank of America.

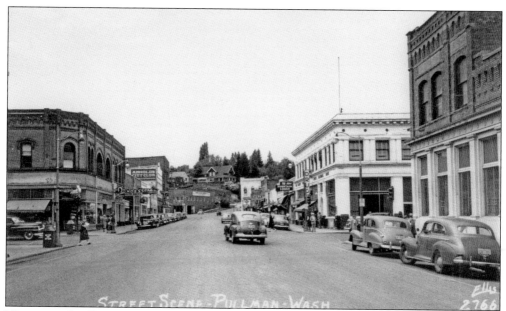

This view of Pullman's Main Street in 1950 is easily replicated today. Although business names have changed, nearly all the buildings remain with the exception of the Corner Drug (left), which was lost to fire in October 2000. Other buildings have been significantly remodeled, including the First National Bank (now Design West) and Pullman State Bank (far right, now American West Bank).

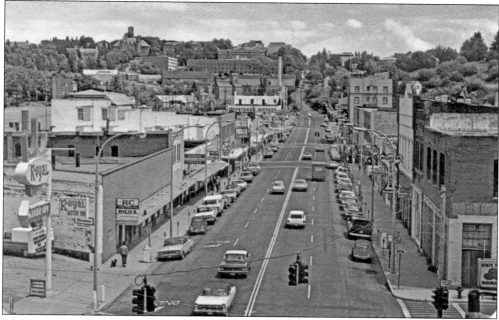

Main Street still carried two-way traffic about 1965 and was lined with thriving stores and businesses. Across the street and farther east from the five-story Washington Hotel was Hofstrand Motors. The WSU campus can be seen in the upper left. The IOOF (International Order of Odd Fellows) building on the far right was still standing at that time, but the top floor, where dances took place in the early 1900s, had been removed.

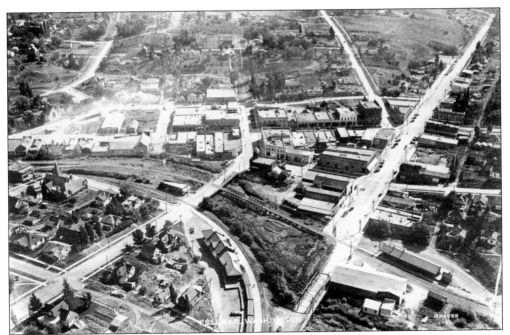

This aerial view of Pullman, looking south, was made in 1921 by the Graves Photography Studio. It shows that the town was well developed on its 40th birthday. In this picture, Kamiaken Street starts near the lower left corner and runs diagonally to Olsen Street, where it bends to go due south. Grand Avenue can be seen running diagonally on the right.

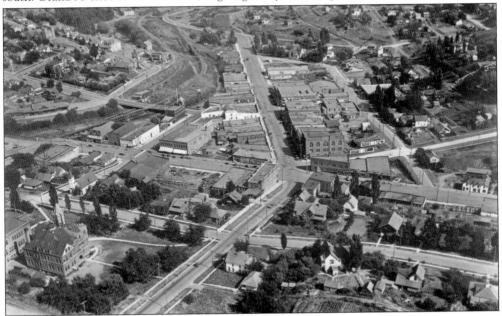

This 1921 bird's-eye view of Pullman looking east from Sunnyside Hill shows the intersection of Main Street and Grand Avenue near its center. The triangular structure there, the Flatiron Building, still stands. The trees in the upper-left are in Reaney Park. The 1892 school, now the site of the Gladish Center, is at the bottom left. Pullman was a quiet town with a population of fewer than 3,000, and Main Street ended at Spring Street (top center).

Four

AT SCHOOL

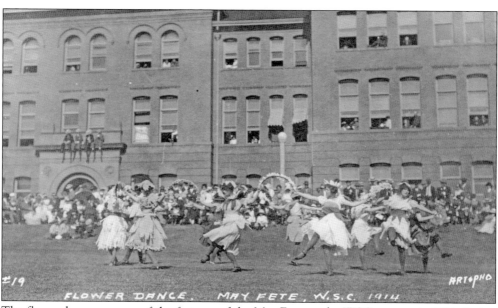

The flower dance was one of the features of the May Fete on the WSC campus in 1914. Spring celebrations were popular in American towns and colleges during the first quarter of the 20th century. The building in the background is Science Hall, built in 1899 to include several laboratories. It is now part of the Murrow Communications Center.

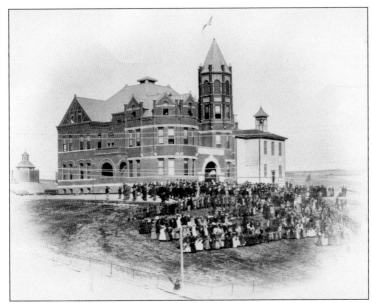

Columbus Day 1892 saw a twin celebration in Pullman, marking both the 400th anniversary of the discovery of the New World and the opening of the town's third public school. All 300 students posed in front of the school near the corner of Main and State Streets. The brick structure cost $30,000. Note the outdoor toilets near the left rear of the building. The wooden structure on the right was Pullman's second school, built in 1887.

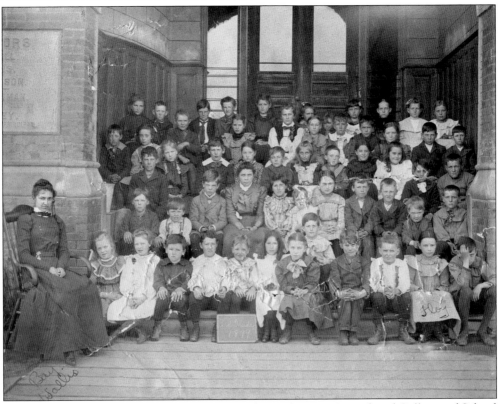

This 1899 third-grade class was a large one. Once the Washington Agricultural College and School of Science had located in Pullman, the town began to grow rapidly. The school, which offered only eight grades at the time, was located on the site of the present-day Gladish Community Center. Floy Bean (second from the right in the first row) was the daughter of Charles W. Bean, principal of the Pullman school. Earlier, he had been Whitman County superintendent of schools.

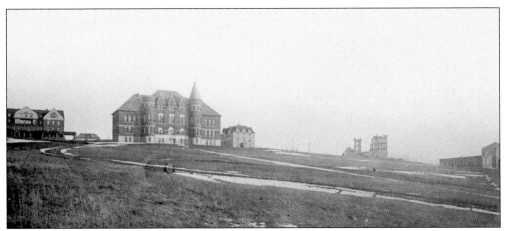

The burned-out steel shell of the men's dormitory at Washington Agriculture College can be seen on the right after it was destroyed in November 1897 by a 2:00 a.m. fire. All 100 students sleeping there escaped without injury. Pullman townspeople came forward with food, clothing, and shelter for the students. From left to right, the other buildings in this picture are Stevens Hall, the Administration Building (now Thompson Hall), old College Hall, and the Mechanical Building at far right.

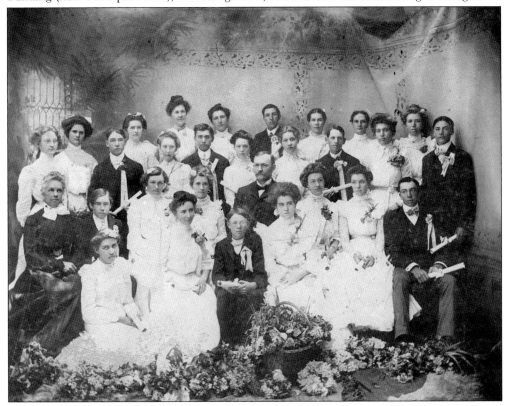

The 1902 graduating class of Pullman High School held its celebration in the Pullman Opera House, located on the southwest corner of Grand Avenue and Blaine. All of the people in the picture are identified on the back of the original photograph. The man in the center of the second row is school superintendent James L. Dumas, who is credited with establishing excellence in the town's schools.

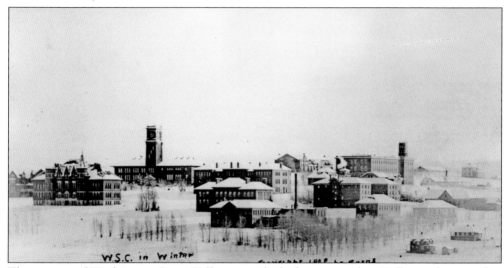

The campus of Washington State College was cloaked in snow when Pullman photographer Robert Burns snapped this picture in 1908. Enrollment in the college that year was 1,300 students, a sharp contrast to the 59 students enrolled when it opened in 1892.

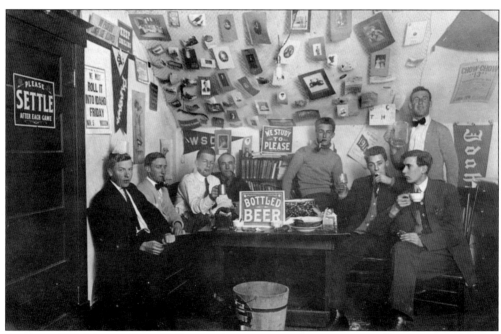

A group of Washington State College students prepares for an evening of serious study in what appears to be a dormitory room in 1910. The enrollment at the college that year was 1,016. Note that seven of the eight studious gentlemen are wearing neckties. In 1959, Washington State College was renamed Washington State University.

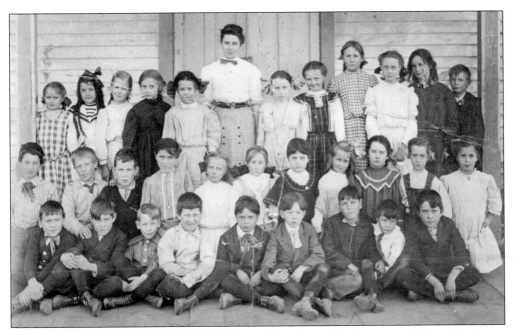

The 1911 fifth-grade class at Pullman's old Edison School poses for the camera with teacher Emma Melvin. The old wooden school they attended, which stood at the corner of Colorado and Ruby Streets, was replaced with a brick building in 1926–1927. Still standing, the building is now called Adams Mall and is used for commercial purposes.

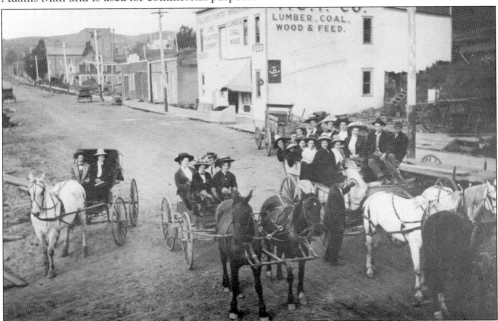

Pullman High School's first four-year class took what was perhaps the school's first senior sneak and picnic on May 3, 1910. The camera is facing south on South Grand Avenue. The Palouse Country Improvement building, in the foreground, later became Pike's Motor Service and then My Office Tavern. Florence Windus is pictured in the left front seat of the four-seat buggy. The multistory building in the distance is the Opera House.

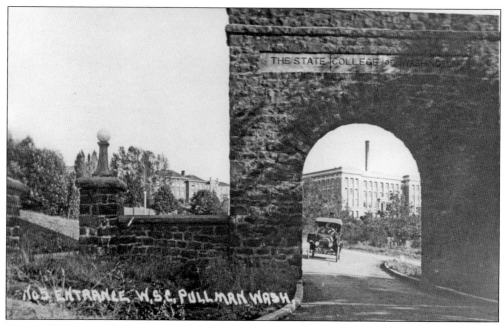

This 1917 photograph shows the old entrance to the WSC campus marked by a stone arch. The Roman arch, a gift from the class of 1905, was 36 feet tall and built of locally quarried basalt. Torn down during the winter of 1955–1956 during a project to widen Oak Street, its stone blocks were saved and used two years later to build the college's entrance sign at Stadium Way. In 2003, a three-quarter-size replica was erected near the arch's former location.

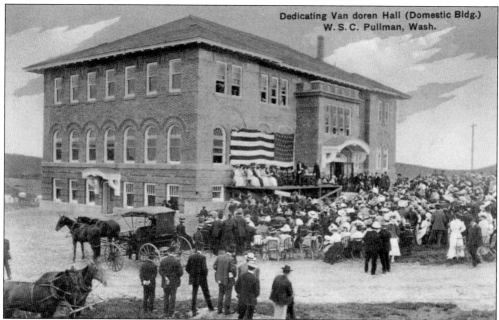

The first WSC building devoted to "domestic economy" (home economics), Van Doren Hall was dedicated in 1908. It was named to honor Nancy L. Van Doren (1842–1922), one of the original WSC faculty members, a professor of English, librarian, and preceptress of the girls' dormitory. The building now houses the Center for Distance and Professional Education.

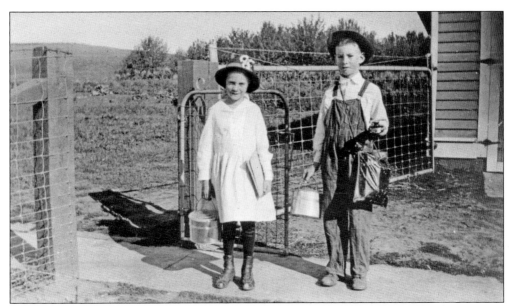

Beryl and Edward Farrand were well prepared for the first day of school in September 1920. In addition to their school supplies, each carried a metal lunch bucket. Edward also appears to be carrying a bottle of ink. Their destination was the Russell School, which was located about 6 miles east of Pullman.

Silver Lake and Tanglewood were cherished features of the Washington State College campus from the 1890s to the 1920s. They were located at the present-day sites of the Hollingbery Fieldhouse and Mooberry Track. The buildings at the center of this 1915 picture are Van Doren Hall and Bryan Hall's clock tower. Silver Lake was nicknamed "Lake de Puddle" by the students.

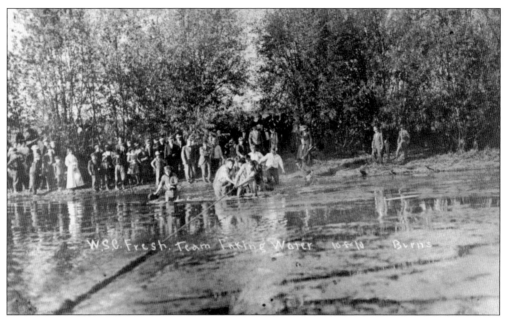

Classic battles between freshman and sophomore teams at Washington State College were waged shortly after the beginning of each fall semester in the early 20th century. In this 1910 tug-of-war, the freshman team is being pulled by the sophomore team into the waters of Silver Lake (commonly called "Lake de Puddle"). The tree-lined lake covered part of the present-day location of the track and field house.

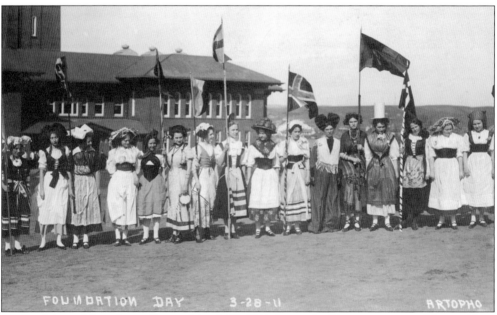

WSC celebrated Foundation Day on March 28, 1911. It was the 21st anniversary of the enabling legislation creating the college, passed in 1890 by the new Washington State Legislature. The day began with a parade that went from the campus to Pullman's downtown and back. Every department participated. On the Foreign Language department's colorful float were women dressed in the costumes of many nations and carrying their flags.

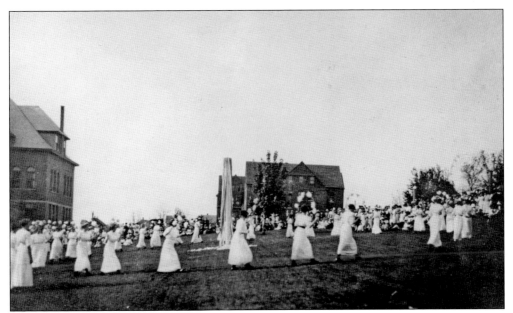

Dozens of young coeds in long white gowns celebrated May-Fete in 1913 on the campus of Washington State College. The event, complete with Maypole, took place approximately where Murrow Hall now stands. Stevens Hall is in the center of this picture, and the Administration Building, now Thompson Hall, is on the left.

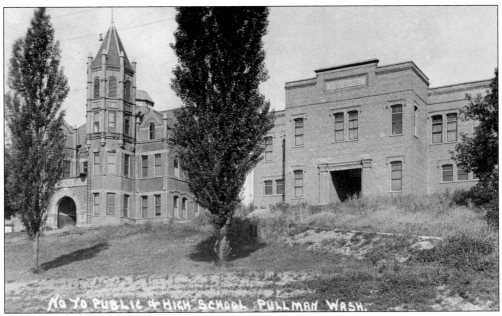

Two Pullman schools stand side by side in this picture from about 1915. They were on the present-day site of the Gladish Center. The building on the left was constructed in 1892. As Pullman's population grew and high school grades were added, the building became increasingly crowded, even with the opening of two elementary schools on College Hill and Pioneer Hill. The building on the right was constructed in 1913 as Pullman High School.

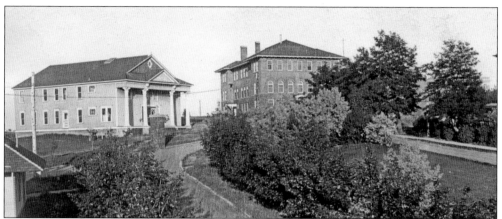

The WSC Music Conservatory, nicknamed "Agony Hall," stands to the left of Van Doren Hall in this 1911 photograph. The inexpensive 1905 wood-frame building contained six studios for teachers, a room for small recitals, and 16 tiny practice rooms, each barely large enough for a piano. It was the first campus building erected with private money. This method was later used to construct Community Hall and other dormitories. Agony Hall was razed in 1963 to make room for the present music building.

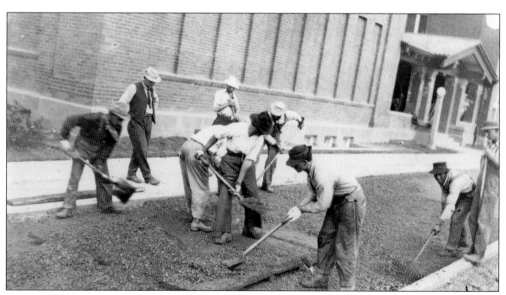

A 1912 paving crew operates near Bryan Hall on the campus of Washington State College. Built in 1908, Bryan Hall housed both the college library and the auditorium. The library was moved across the street in 1950 when the Holland Library building was completed.

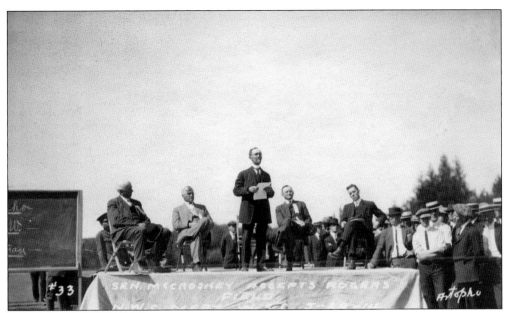

Rogers Field, on the campus of Washington State College, was presented on May 29, 1914, to Robert C. McCroskey, who represented the college's board of regents. McCroskey, in turn, presented the athletic field to the student body, which was represented by the associated student body president, James Williams. McCroskey, a state senator, was a prominent farmer and banker from Garfield, Washington.

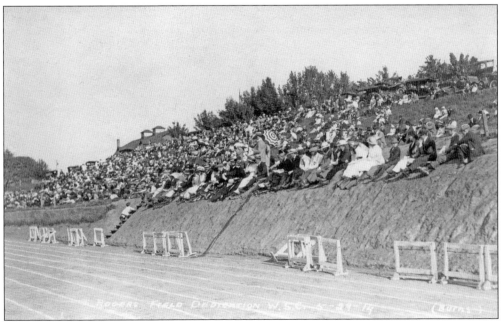

Immediately following the Rogers Field dedication ceremony in May 1914, the six colleges of the Northwest Conference held a track meet here. Five conference records were set that day. Rogers Field served as the site for WSU's outdoor athletic events until 1969. A wooden grandstand replaced hillside seating in the 1920s, and the structure was completely rebuilt in 1936.

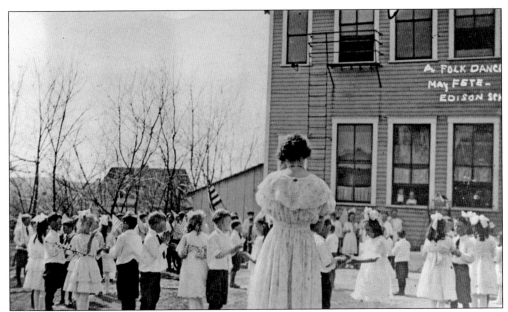

Students at the original Edison Elementary School celebrated a May Fete and folk dance in 1917. The girls wore frilly white dresses and white bows in their hair, while the boys were outfitted with white shirts, dark ties, and dark knickers. This two-story wooden structure, built in 1907 for $3,000 on the corner of Ruby and Colorado Streets, was replaced at the same site in 1927 by a brick building, also named Edison, which is now the Adams Mall.

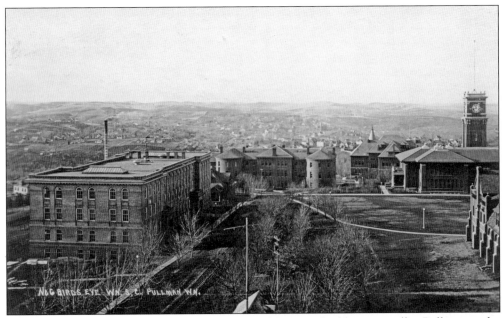

This *c.* 1914 view of the WSC campus shows some of the main buildings, as well as Pullman in the distance. From the left, the buildings are College Hall, Science Hall (now Murrow Communications Center), the Administration Building (Thompson Hall), the Library and Assembly Hall (Bryan Hall), and a small part of the Crib, which contained the gymnasium and armory. Terrell Library now occupies the site of the Crib.

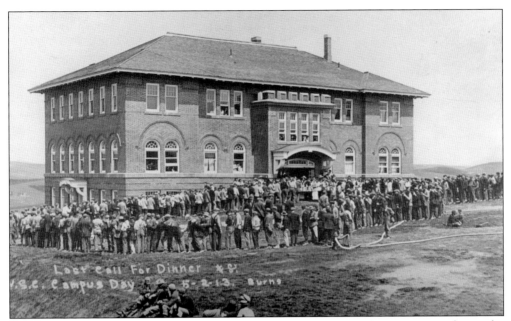

Campus Day at WSC was an early May tradition from 1912 to the early 1930s. Not only was the campus improved, but the effort also helped to build school spirit. In this 1913 picture, hungry workers are lined up for a noon dinner prepared by some of the women. More than 1,000 workers (out of a total enrollment of 1,400) poured 750 feet of sidewalk, laid 30 wagonloads of sod, and cleared enough debris and brush to fuel a house-high bonfire that evening.

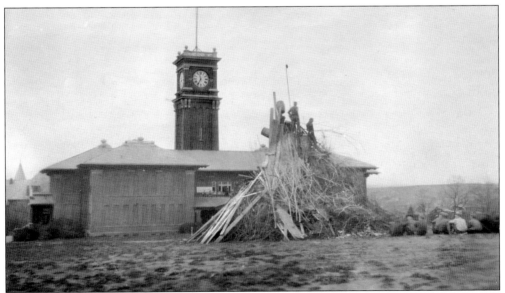

The homecoming bonfire on the campus of Washington State College was built bigger than ever in November 1919. That fall, the school had resumed intercollegiate football after the interruption caused by World War I. The opponent the next day was the University of Washington, for whom 700 stadium seats had been reserved. Washington State lost 13 to 7.

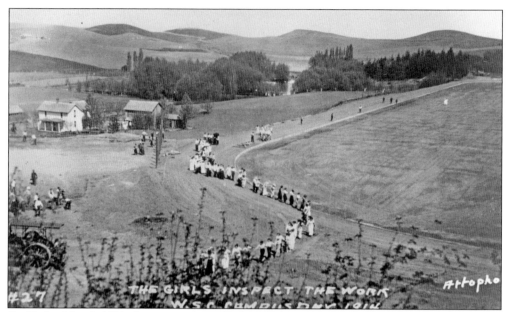

On Friday May 1, 1914, classes were cancelled for Campus Day, and over 1,000 students worked cleaning and beautifying the campus. Typical projects were the building of four tennis courts and the construction of an "artistic rustic" bridge across the end of Silver Lake. A small part of the lake can be seen at the top center of the picture. Many of the women worked at preparing and serving a lunch just south of Van Doren Hall.

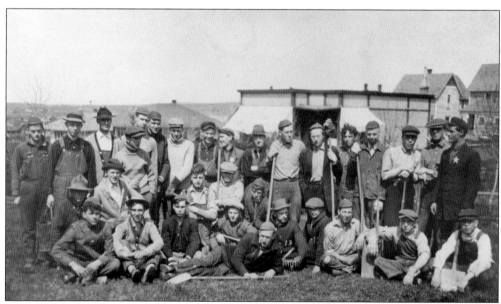

WSC Campus Day in spring 1913 saw students and faculty alike turned out to work on a variety of projects ranging from building sidewalks to clearing brush from the hillsides. Many of the women prepared a noon meal for the other workers. Equipped with rakes and shovels, the men here in squads eight and nine appear to be prepared for some serious cleanup.

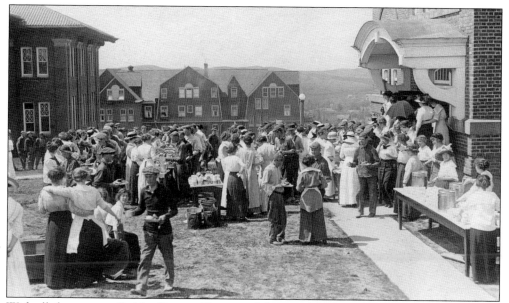

With all classes cancelled for Campus Day, men did most of the heavy work on the day's projects. While the women were involved in a variety of tasks, many worked long and hard to prepare and serve the noon dinner for more than 1,000 workers. The buildings in this picture are, from left to right, Bryan, Stevens, and Van Doren Halls. All are still standing.

Seen here around 1931, Pullman High School included both senior and junior high school students and occupied three buildings. Viewed from West Main Street, the first building on the left is the 1929 building, which is today a part of the Gladish Center. Next is the 1892 building and tower, damaged so badly in a May 1933 fire that it was torn down. At far right is the 1913 high school building, demolished in the 1950s for construction of an auditorium wing.

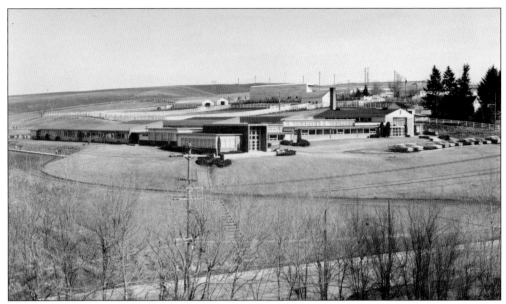

The "New" Edison School in Pullman was built in 1948 to accommodate the surge in enrollment after World War II as married veterans with families flocked to Washington State College. The school was located on Stadium Way at Valley Road. Behind the school in this c. 1960 picture are the Hilltop Stables. The school was closed in the early 1980s, and the building was demolished in the early 1990s. Apartments now occupy the site.

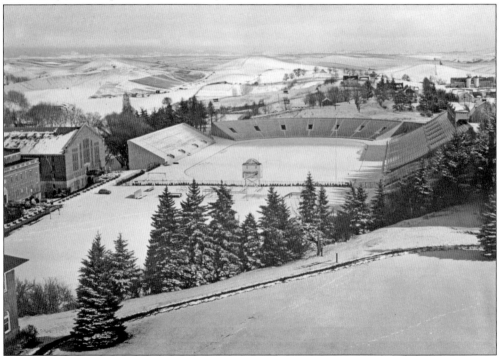

The campus of Washington State College lies peacefully under a blanket of snow in this 1930s photograph. In the center is Rogers Field, the predecessor to today's Martin Stadium. On the left are Bohler Gym and Hollingbery Fieldhouse.

The old campus post office at WSU was knocked down in less than one day in February 1964 to make room for construction of Kimbrough Music Building. It had also housed the YMCA, but both the post office and the "Y" had moved earlier to the Compton Union Building. The two-story frame structure was constructed for $9,000 in 1926 as a "temporary" building. In its final years, it housed about 150 monkeys being used in scientific research on sight problems.

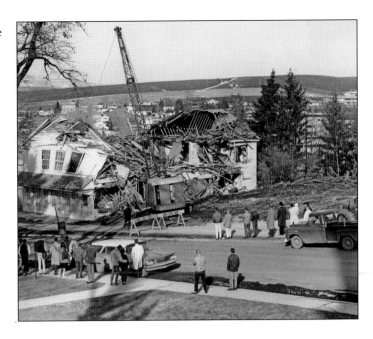

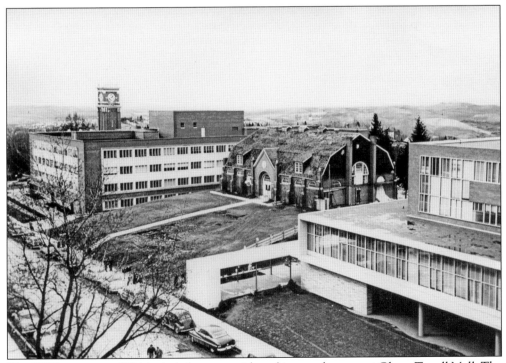

The WSC campus in 1954 included a street with parking on the present Glenn Terrell Mall. The buildings visible are the Bryan Hall tower, built 1908; Holland Library, 1950; the Gymnasium, 1901; and the Compton Union Building, 1952. After Bohler Gym was built in 1928, the Gymnasium became the Women's Gymnasium; in 1945 it was converted into the Temporary Union Building (TUB). It was torn down in the 1950s, and Terrell Library now occupies the site.

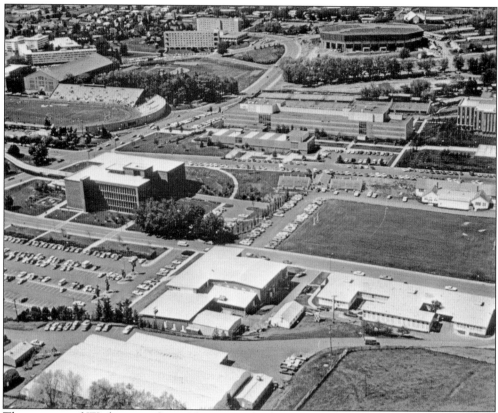

The campus of Washington State University displays much new construction in this aerial photograph taken looking north in June 1972. At top center, Stadium Way curves to the northwest with Beasley Coliseum to its right and dormitories for women on the left. Also on the left is Martin Stadium, then newly built. Below it is the Administration Building.

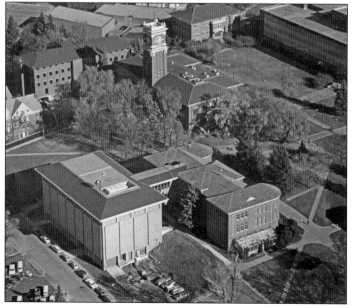

Murrow Communications Center on the Washington State University campus is shown here in an aerial photo taken when it was dedicated. The new portion (left foreground) was constructed in 1980. The older part (right foreground) was the university's original science building, which had been built in 1899. The rounded portions facing east had been designed to provide suitable lighting for classes using microscopes.

Five

At Home and Church

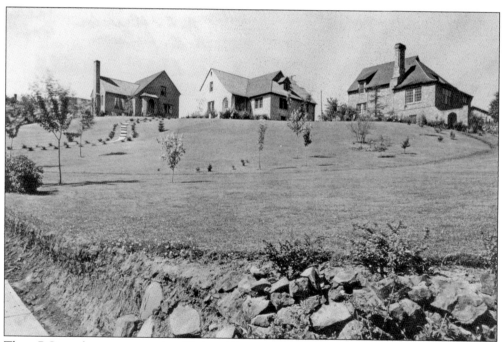

These B Street houses are now in a National Register Historic District. Prof. Stanley Smith of the WSC Architecture Department designed and built the homes in 1927 for three other professors at the college. He was assisted by Fred Rounds and Harry Weller. The homes, from left to right, were for B. L. Steel of the physics department, A. E. Drucker of mining, and H. E. Culver of geology. The total cost of the homes was about $30,000. The photograph dates from the late 1920s.

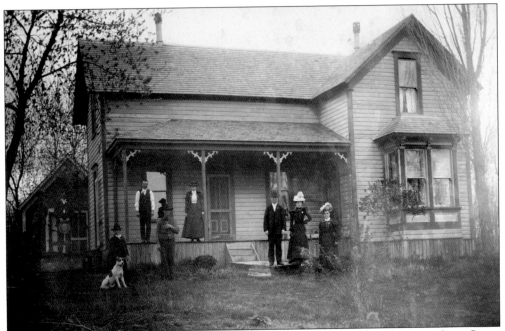

The Parker family posed for photographer Lachlan Taylor in front of their home on State Street in April 1900. The Parkers farmed land between Pullman and Palouse. Patriarch James R. Parker (1848–1931) is the man wearing dark clothing, second to the left of the door. Youngest son, James A. Parker, is the boy with the dog at left. An older son, Edwin E. Parker, is at right with his wife Nora May and their daughter Etta.

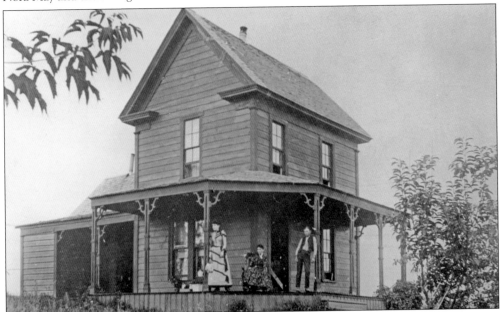

The early Pullman home of Mary E. Elbert (1840–1923) stood for many years on the northeast corner of Spring and South Streets. Elbert, known as "Grandma" Elbert because of her many grandchildren, moved to this home in 1887 when her husband George Elbert died. He was superintendent of the Sunday school of the Pullman Methodist church during its earliest years.

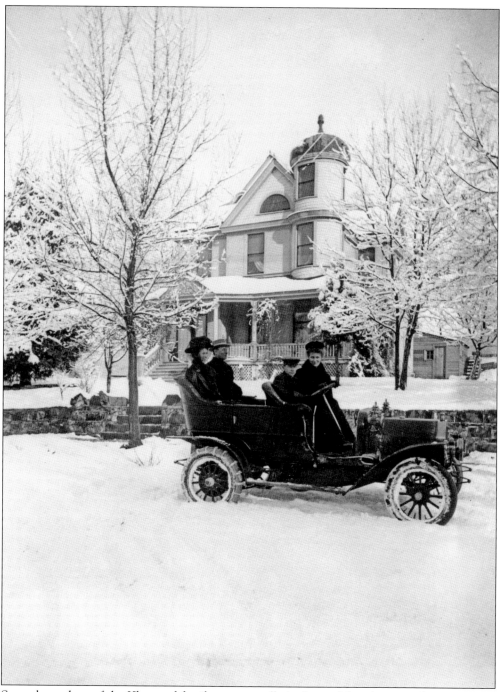

Several members of the Klemgard family pose proudly in front of their home in their new 1909 Stoddard Dayton automobile. Seated in back are Nora and James S. Klemgard; in front are their daughter Flossie and son Gordon (at the wheel). Their home, located on Morton Street next to Reaney Park, was torn down in the 1970s. Klemgard (1865–1931) was active in civic affairs and served as county commissioner and bank vice president. He owned more than 2,500 acres of farmland in the area.

Seen here festooned with hop vines in the 1890s, the Pullman home of John and Almira West stood on Dexter Street. The house, built in 1882, is still standing, although a wing on the east side was removed in the 1930s. The Wests' son, Otho, is shown on a bicycle in front of the porch; behind him and to the right is the boy's aunt, name unknown. John West ran a second-hand store on Main Street, which his son subsequently operated from 1912 to 1945.

The home of James and Fannie Dumas on Ruby Street was blanketed with snow in 1913. James Dumas was Pullman's first superintendent of schools and was instrumental in establishing the four-year high school. On the walk is his two-year-old son Edwin A. Dumas, who later headed the Dumas Seed Company and helped develop new uses for dry peas. For many years Acacia Fraternity was located on this site on College Hill at 725 Ruby Street.

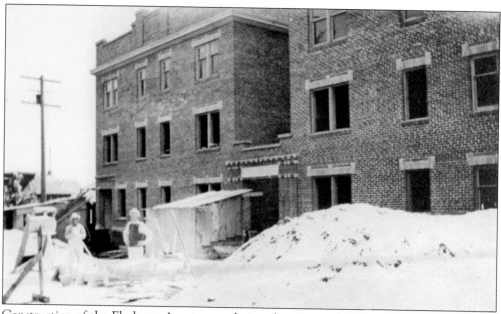

Construction of the Elmhurst Apartments during the winter of 1921 was not halted by snow. Built by F. V. Roth of Roth Construction Company, the 20-unit structure opened that August as the Roth Apartments. The name was changed to Elmhurst Apartments in the mid-1920s. The apartments are still in use at 405 Oak Street on College Hill.

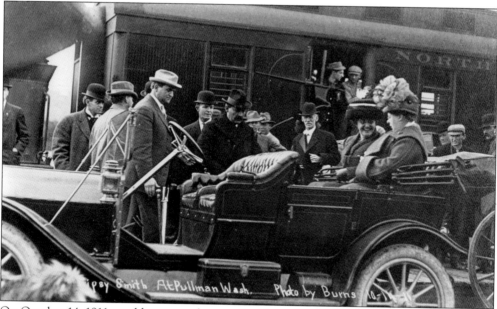

On October 14, 1911, world-renowned evangelist Gypsy Smith arrived at the Northern Pacific depot for a four-hour visit. An estimated 2,000 people crowded into the 1,200-capacity College Auditorium (now called Bryan Hall) to hear his sermon. It was described in a newspaper account as being delivered in a "wonderfully low, musical voice . . . not a sermon of blood and thunder and Hell."

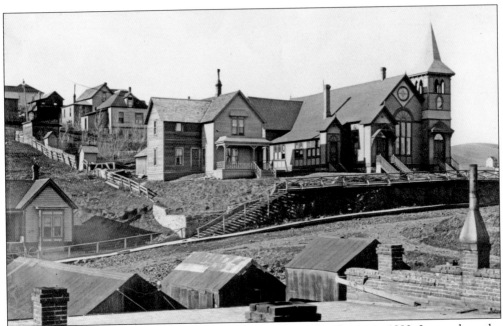

The Congregational Church dominates this view of Paradise Street in 1892. Located on the southeast corner of the intersection of Paradise and High Streets, it was torn down in 1916. The parsonage, left of the church, was extensively remodeled in the early 1970s. It housed the Season's Restaurant until the late 1990s. Note that the street is unpaved. Two outhouses stand next to the fence on the left.

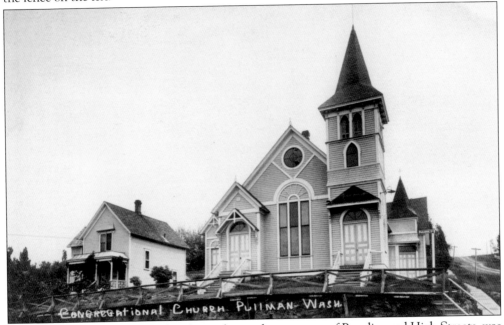

The Second Congregational Church, on the southeast corner of Paradise and High Streets, was built in 1891 and used for the next 25 years. Their first church had been built on the same site in 1886, but it was destroyed in Pullman's great fire of July 1890. The house to the left of the church served as the parsonage. It later housed the Season's Restaurant and is still standing today.

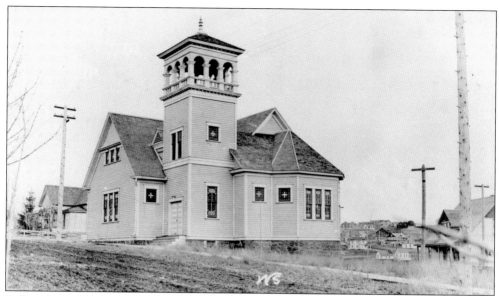

Pullman's first Presbyterian church was completed in April 1899 at a cost of $4,000, including furnishings. State College president Enoch A. Bryan purchased the lots and led the drive to build the church. When a bigger church was needed, this building was jacked up, rotated, and incorporated into the new structure, which became known as the Greystone Church. Its transformation was completed in October 1914 at a cost of more than $50,000.

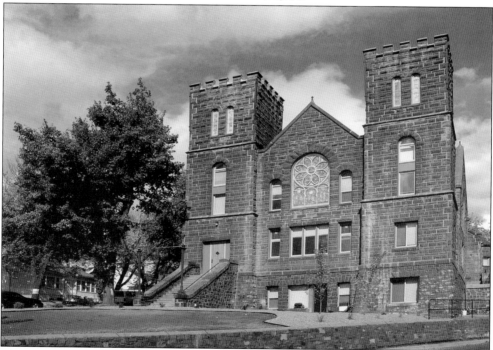

The historic Greystone Church was saved from the wrecking ball in 2005 when it was remodeled and converted into a multi-unit apartment building. Part of the structure dates back to a wooden 1899 structure. The Greystone Church building remains a prominent Pullman landmark at the intersection of Whitman and Maple Streets with Maiden Lane.

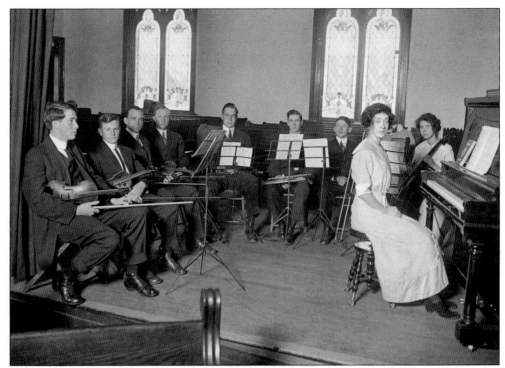

The Methodist Orchestra once provided music at Simpson Methodist Church. Seated at the piano is Hettie Cave Hix. Hazel Waters on the cello is at the far right. On the left are violinists Ray Tuttle and Asa Bradrick. This photograph is undated, but it appears to have been taken between 1915 and 1920.

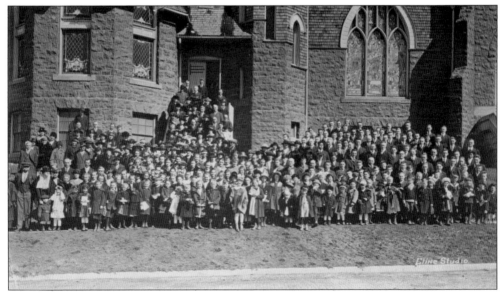

The Simpson Methodist Church Sunday school posed for this photograph about 1924. The stone church in this picture stood on Maple Street just south of the present Methodist church. The Methodists were the first religious group to organize in Pullman. In 1882, services and classes were held in the Daniel McKenzie cabin, which stood about on the present site of the motel at 455 Paradise Street.

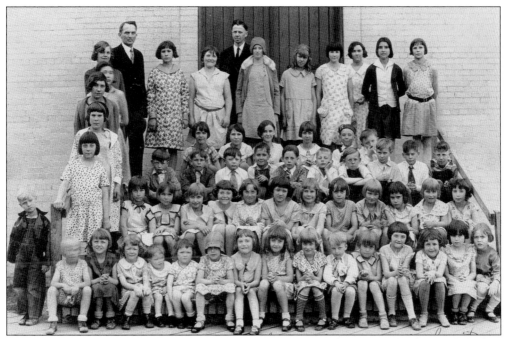

Vacation Bible School at the Baptist church in Pullman had about 60 children enrolled when this picture was taken around 1930. Standing at left in the top row is Rev. W. E. Monbeck. Many of the children in this picture have been identified; their names are on file with the Whitman County Historical Society.

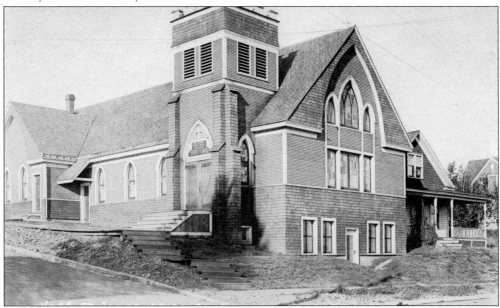

St. James Episcopal Church of Pullman, built in 1912 at the corner of Oak and Ruby Streets, was designed by Pullman architect William Swain and cost $5,345. The cornerstone was laid September 12, and the first services were held December 8. Services continued here until 1955 when the church moved to its present location on Stadium Way. The building shown here is still standing, but it is almost hidden by trees and shrubs.

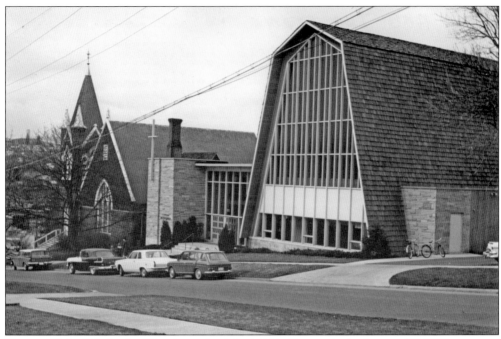

Simpson United Methodist Church, on the right, held its first service in the new $175,000 sanctuary on May 18, 1958. On the left is the old stone Methodist church, which cost $25,000. It was dedicated January 24, 1909, and demolished in 1966, shortly after this photograph was taken.

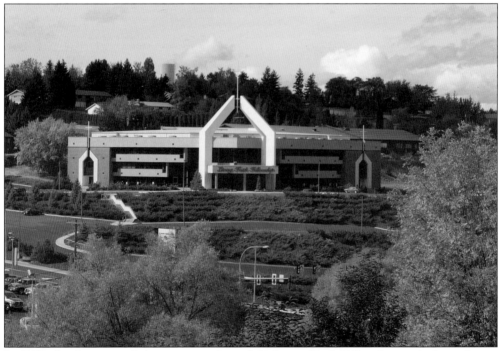

In 1995, after five years of planning, members of the Living Faith Fellowship worked together to complete a new worship center with a large auditorium on South Grand Avenue. The Living Faith Fellowship was incorporated in 1971 and purchased the land on South Grand Avenue in 1983.

Six

PULLMAN AT PLAY

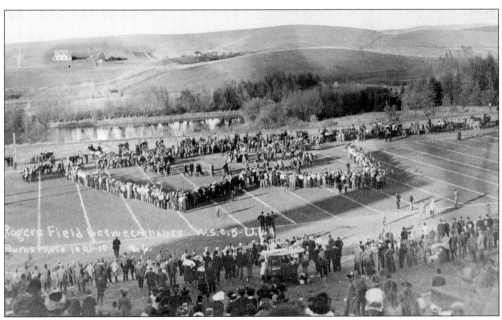

The annual Battle of the Palouse football game between Washington State and the University of Idaho dates back more than 100 years. Taken during halftime of the 1910 game, this photograph depicts Silver Lake, now the site of Mooberry Track. Much has changed in Pullman, including the existence of a Martin Stadium, where Rogers Field once stood, but the field has hardly moved. The winner that year was Idaho, 9–5.

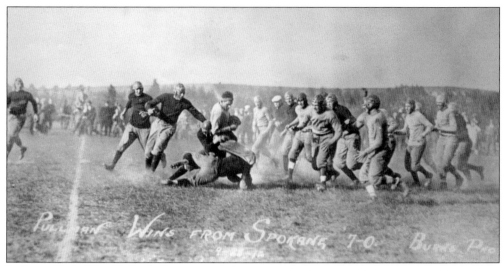

Pullman High School's football team, in light gray uniforms, upset Spokane's Lewis and Clark High School, 7–0, in this 1912 game. The Spokane team expected an easy practice game, but it was outplayed by the Pullman players, who were described as "light but quick," their heaviest player weighing only 170 pounds. In the early days of high school football in eastern Washington, Pullman was a football powerhouse. Pullman was county champion every year from 1910 to 1915.

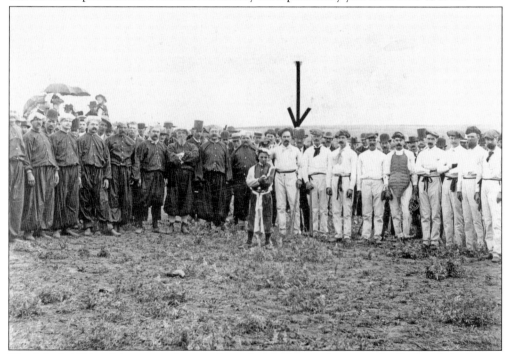

The July 4, 1891, celebration culminated in a baseball game between the Fats and the Leans, all leading citizens. Pullman had much to celebrate that year; the town had rebuilt after a devastating 1890 fire and been selected for the Washington Agricultural College. The man in the hat under the arrow is Bowlin Farr, Pullman's first homesteader. The Fats were clothed in bright red Turkish trousers and full blouses; the Leans wore tight-fitting white pants and shirts. The Leans won, 12–4.

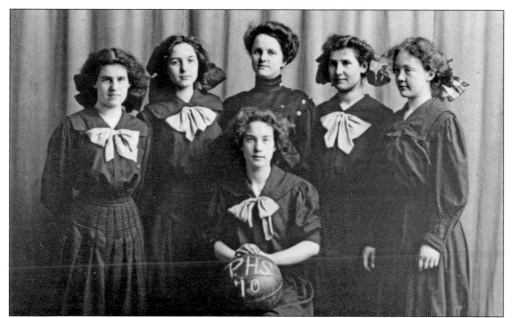

The 1910 Pullman High School girls' basketball team posed for this picture. From left to right are (seated) Mary Humphrey (Todd), (standing) Helen Quarles (Raymer), Melcina LaFollette (Knettle), second-grade teacher Lona Hedloff (Bryant), Nell Emerson, and Grace Baker. Names in parentheses indicate their surnames after they married. Note that the girls are wearing their hair down or in pigtails, while Hedloff, presumably their coach, is wearing her hair up.

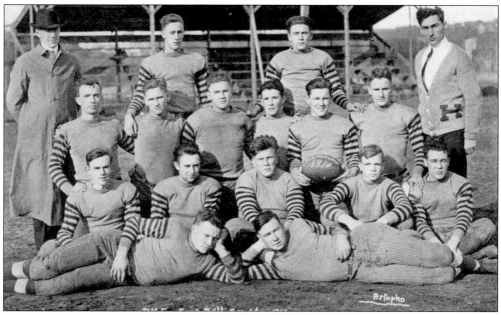

In 1914, the Pullman High School football team won the Whitman County Championship for the fifth straight year by beating Colfax High School, 72–0. The Pullman teams were gridiron powerhouses in that era. Pullman scored a total of 340 points to their opponents' 6 during the 1912 season. In this picture, principal Elmer L. Breckner is standing at the rear left, and coach A. E. Scheer is at right.

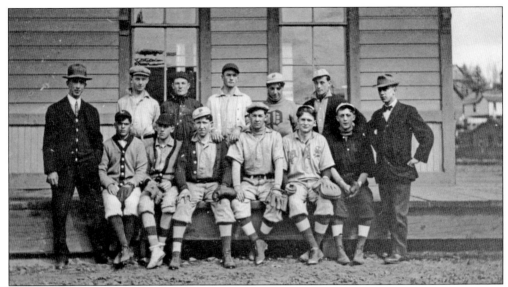

Members of the 1910 Pullman High School baseball team wait at the Union Pacific depot, probably on the way to play their archrivals at Colfax High School. Standing at the left is manager Clarence Hix, later bursar for WSC. In the back row, fourth from the left, is pitcher Norman Moss, who later joined his father building homes in Pullman. The wooden depot was replaced in 1939 with a brick one, which is now the WSU Visitor Center (Cougar Depot).

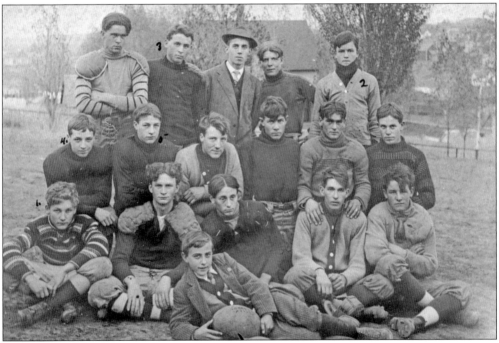

The 1908 Pullman High School football team was coached by Allen C. Conger (back center, wearing hat). Prior to this November photograph the team had lost to Garfield, played a 0–0 tie with Palouse, and lost its sponsorship by Pullman High School. Nevertheless, the players formed a team coached by a member of the college team. The Pullman team traveled to nearby Moscow and defeated Moscow High by scoring 18 points in the second half.

The Pullman High School girls' basketball team posed for this picture in about 1914, with their "uniforms" of black stockings, bloomers, and middy blouses. From left to right (seated) are Lenore Emerson, Alta Hammond, Corrine Barclay, Etta Hampson, Thelma Moss, Ruth McCarthy, Pearl Rice, Lelah Burgess, coach Rowena Bond, and Ruth Leuty. Standing behind them are Evelyn Cochran and ? Walters.

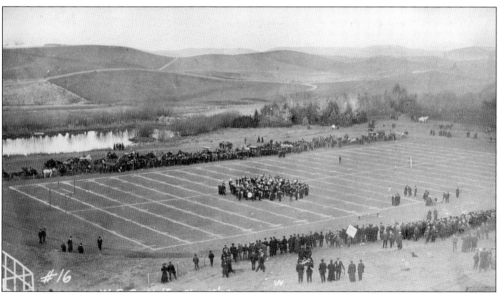

Archrivals Washington State College and the University of Idaho met in the Battle of the Palouse on November 13, 1908, at Rogers Field. Despite the lack of seating, more than 1,000 spectators cheered from the sidelines. The afternoon was enlivened by nearly 250 musicians from local town bands. Silver Lake can be seen just beyond the football field. As for the game, it ended in a 4–4 tie, each team having kicked a field goal.

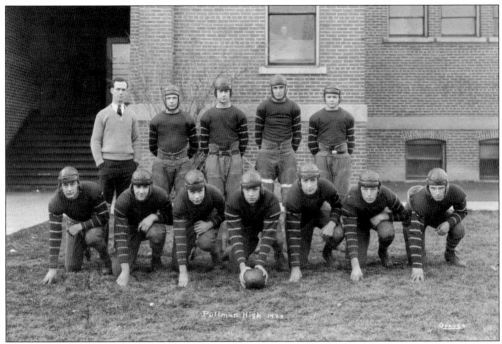

The 1923 Pullman High School football team had a very successful season, winning seven games while losing only once. Their coach was Charles A. McGlade, second row at left. The team scored a total of 211 points while holding the opponents to 34. Best of all, they were victorious over archrivals Moscow and Colfax.

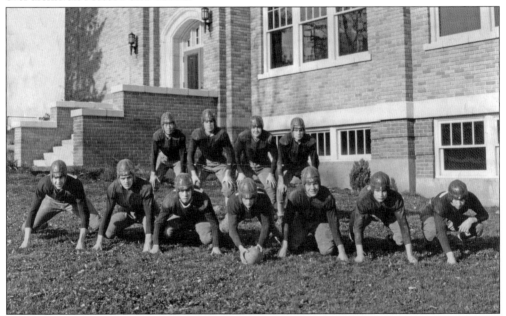

The 1933 Pullman High School football team won the Whitman County Championship after losing its first game to Moscow. In the backfield of the starting lineup were Chang Eng, Willard Patterson, Hugh Lingg, and Virgil Gass. On the line were Claire Dickerson, Wendell Gwinn, Dan Hood, George Felger, Conrad Henry, Harlan Glover, and Howard Halpin.

Seen here is the backfield of the 1914 Pullman High School championship football team. From left to right are Bob Moss, Glen Glover, Fred Glover, and Art Henry. Pullman won the Whitman County Championship in its final game of the season by walloping the Colfax High School team, 72–0.

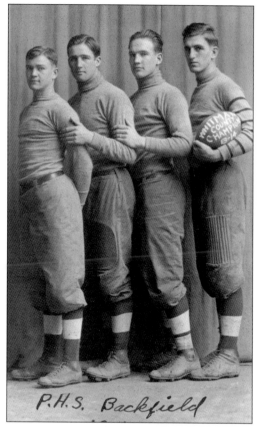

P.H.S. Backfield

The Pullman Cubs were one of two town baseball teams that competed with other area teams in 1910. Pictured here from left to right are first baseman Lloyd Finley, second baseman Hugo Klossner, pitcher John Evans, and outfielder Will Klossner. The Star Livery Stable, behind the players, was located on Grand Avenue just north of the present-day Neill Public Library. Will Klossner and a third brother, Eric Klossner, enjoyed long careers with the U.S. Postal Service in Pullman.

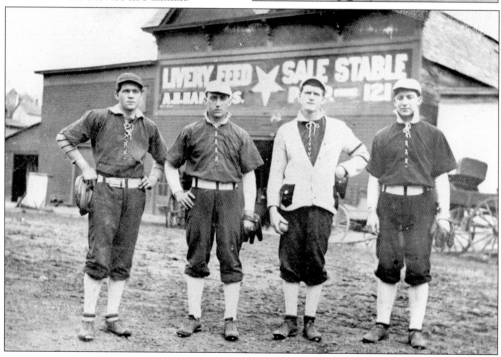

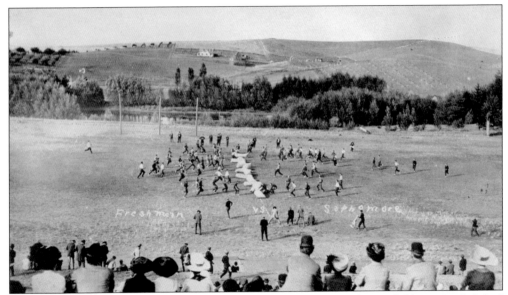

WSC's 1911 freshman and sophomore teams clash on the campus playing field in a "sack fight." Such competitions were common at American colleges a century ago, but they usually assumed a different form each year. This photograph was taken looking north from a position at the present-day site of the Compton Union Building. Silver Lake is visible to the left rear, now the site of the track and field house.

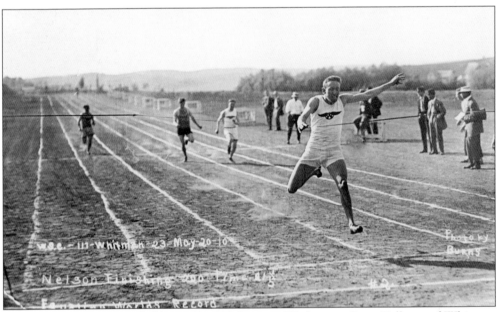

In a track meet in Pullman held May 20, 1910, between Washington State College and Whitman College of Walla Walla, WSC's Jack Nelson tied the world record for the 220-yard sprint with a time of 21.2 seconds. WSC prevailed in the meet by a score of 117 to 23.

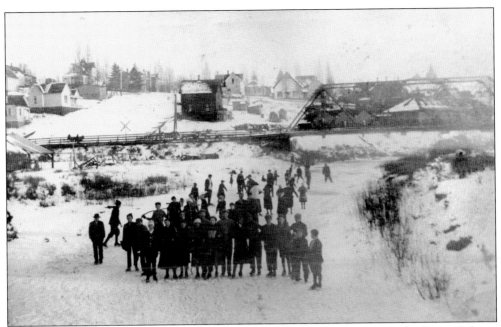

In this c. 1913 photograph, Pullman ice skaters are having a great time on the frozen Palouse River. This picture was taken from the State Street Bridge looking toward the old Grand Street Bridge. On the left is Whitman Street. On the right, the wooden Northern Pacific depot can be seen through the superstructure of the old Grand Street Bridge.

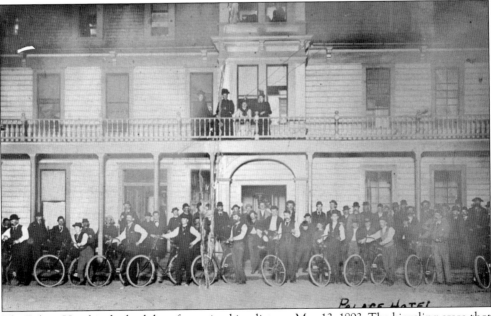

The Palace Hotel is the backdrop for posing bicyclists on May 13, 1893. The bicycling craze that swept America in the 1890s came to Pullman on this warm evening when this early flash picture was taken. The Palace Hotel, built in 1883 on the site of Pullman's current city hall, was moved in 1889 on rollers to the southwest corner of Main and Pine Streets, where Basilio's Restaurant now stands. The hotel was destroyed by fire in 1909.

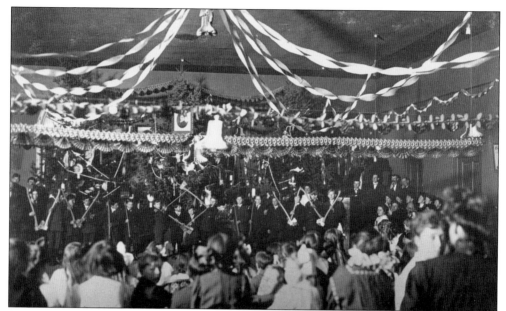

A 1908 Christmas program of the Woodmen of the World (WOW) fraternal lodge took place in the third-floor ballroom of the International Order of Odd Fellows Hall. Shown here are 16 boys performing a drill in which they have formed the acronym "WOW" with sticks. The IOOF Hall, at 205 Main Street, was demolished in the mid-1970s and replaced by the one-story business structure. The members of these lodges worked for the betterment of the community and enriched the social life of the town.

Boating on Silver Lake in 1915 made for a pleasant on-campus date at Washington State College. The pond, popularly called "Lake de Puddle" by the students, was surrounded by an area of greenery known as Tanglewood. It was located approximately on the present-day sites of the Hollingbery Fieldhouse and Mooberry Track. The young women in the boat are Irene Jinnett and her cousin.

Popular Fourth of July celebrations in the early 1900s were held about 10 miles southwest of Pullman at Lyle's Grove near Ewartsville. In this picture from about 1909, the two men seated in the buggy are Pullman merchants A. B. Baker and J. T. Smith. The man in the white shirt standing at attention front and center is John Squires, also of Pullman.

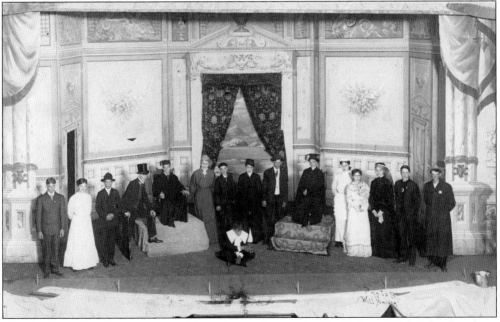

The Merchant of Venice was presented in an "up-to-date version" by Pullman High School students at the Pullman Opera House in June 1905. The opera house, which burned in 1910, was located at the corner of Grand Avenue and Blaine Street, now the location of Associated Brokers Real Estate. Julia Johnson, center, played the part of Nerissa and Isaac Buckley, to her right, played Bassanio. Isaac married Julia on October 25, 1910.

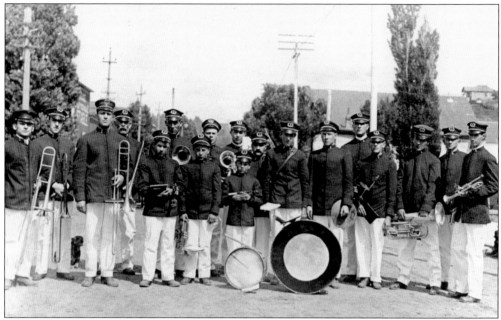

The Pullman Citizens Band was organized during the summer of 1912 with Edward N. Hinchcliff as its leader. The manager was trombonist Lou Wenham, the tall man fifth from the right, next to the pole. Wenham was the editor and publisher of the *Pullman Tribune*.

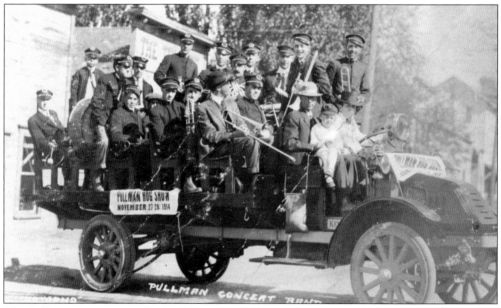

The Pullman Concert Band helped advertise Pullman's third annual hog show, which was held December 11 and 12, 1914. (It had been postponed from the November 27 and 28 date shown on the sign.) The show was a big success, with over 400 porkers competing. The truck is in front of the *Pullman Tribune* building in the 400 block of East Main. Trombonist Lou Wenham's *Tribune* competed with the *Pullman Herald* from 1891 to 1919.

A bobsled pulled by two horses carried this party of holiday revelers near the campus of Washington State College about 1912. The driver of the sled was Murray Henry (1865–1948), a prominent Pullman businessman and restaurateur who came to Whitman County in 1879.

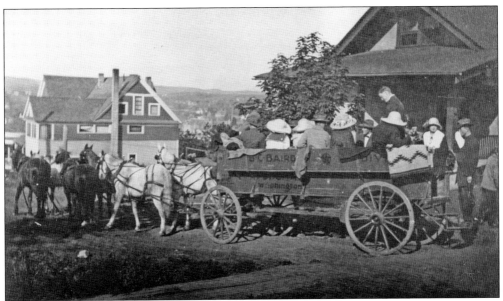

Leaving for a picnic on Moscow Mountain about 1914 are members of the Sigma Phi Epsilon fraternity and their guests. One member ruefully noted, "It took half a day to go over, and half a day to come back—there wasn't much time for a picnic!"

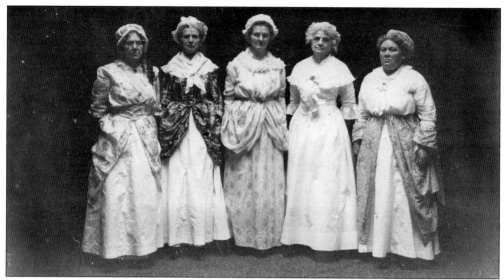

A 1912 patriotic celebration in Pullman featured five women wearing vintage costumes. From the left they are Anna Brooks, Almira Sanborn, Lou Henry, Eliza Struppler, and Lula Downen.

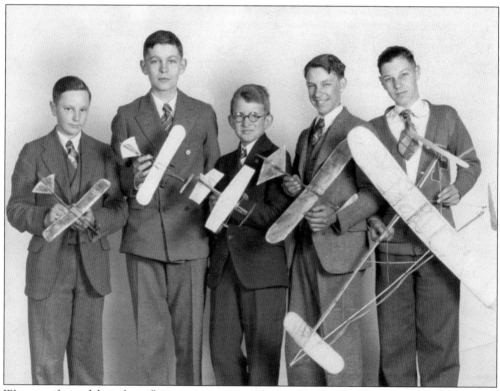

Winners of a model-airplane-flying contest pose with their hand-built planes in April 1929. Cedric Allen won first prize. Other winners included John Nasmyth and Clarence Schuchmann. The making and flying of model airplanes were popular activities for young and old alike in the early 20th century.

Seven

DISASTERS

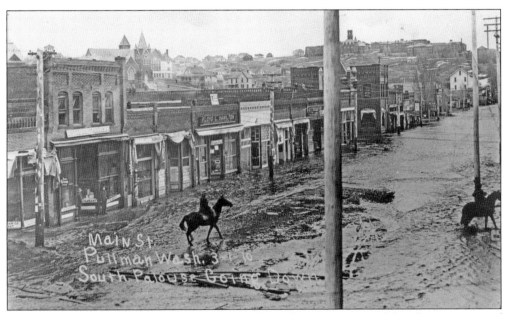

Pullman's worst flood occurred on the morning of March 1, 1910. Here on Main Street just east of Grand Avenue, two boys on horseback have arrived to view the damage. It is late afternoon, and most of the floodwaters have receded, but the massive cleanup must wait for the next morning. A note on the back of the photograph identifies one of the boys as Ken Gray, age 14.

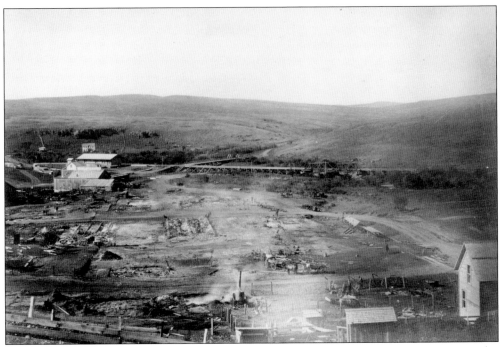

Most of downtown Pullman was destroyed by fire on June 26, 1887. Photographer Lachlan Taylor took this picture from near McKenzie Street, showing the rock outcrops of Military Hill near the top left. The white house just below is the home of pioneer settlers Bowlin and Sarah Farr. It still stands on Park Street. The long white roof just below that is the Oregon Railroad and Navigation Company depot. The WSU Visitor Center now stands at that site.

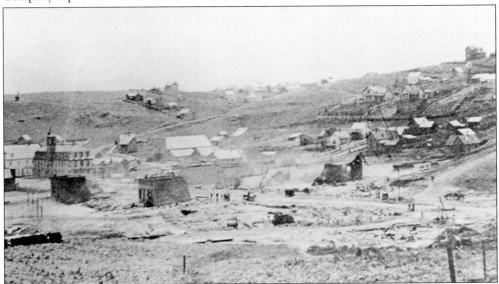

On July 3, 1890, downtown Pullman was again destroyed by fire. In this view looking southeast from Military Hill, the intersection of Grand Avenue and Main Street is at the right in the middle ground. Two burned-out buildings are seen in the first block east on Main Street. The Palace Hotel, with a tower, survived at the corner of Main and Pine Streets. Main Street was immediately rebuilt in brick.

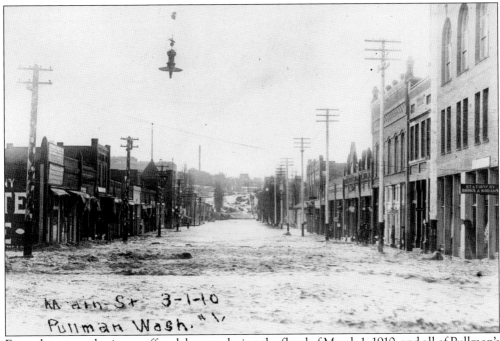

Every downtown business suffered damage during the flood of March 1, 1910, and all of Pullman's bridges were crushed or carried away. Floating timber broke out plateglass windows, exposing stores and other businesses to considerable damage. College Hill was isolated from the rest of the town. In this look east down Main Street from Grand Avenue, the WSC campus can be seen in the distance. Note the streetlight hanging high above the left side of the street.

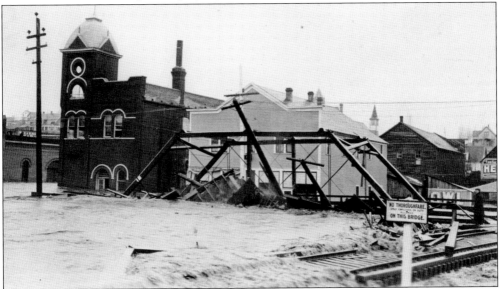

The 1910 flood was sweeping away the Alder (now Kamiaken) Street Bridge over the Palouse River when this picture was taken. A short time later, the gray wooden building in the center, the Palm Café and Rooming House, was also swept downstream, where it broke into pieces. The building left of the Palm Café was the Pullman City Hall, which survived the flood. These two buildings occupied the west side of Alder Street between Olsen Street and the river.

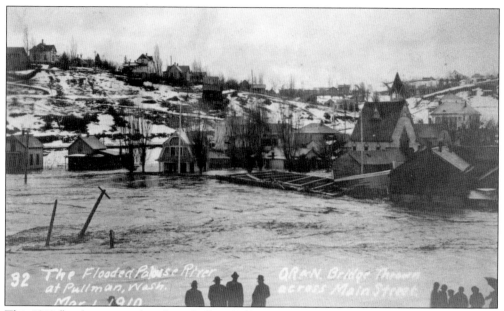

This 1910 flood picture, taken from College Hill near Maiden Lane, shows the Oregon Railroad and Navigation Bridge being pushed across East Main Street. When the flood destroyed a nearby furniture warehouse on Main Street, a piano and several coffins were reportedly swept downstream as well. On the right is the old Baptist church (corner of Main and Spring Streets), and to its right is the home of John and May Squires on Daniel Street, which still stands today.

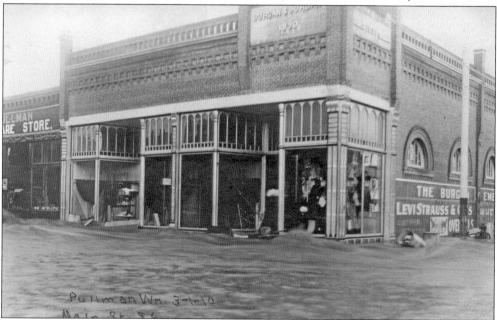

The Burgan-Emerson Mercantile was one of the many businesses that suffered damage during Pullman's 1910 flood. High water was about a foot above the level shown here. Built in 1890, this store at the northwest corner of Main and Kamiaken Streets became the Emerson Mercantile in 1912. This building burned in 1916, and the Emerson Mercantile relocated to the southeast corner of the same intersection.

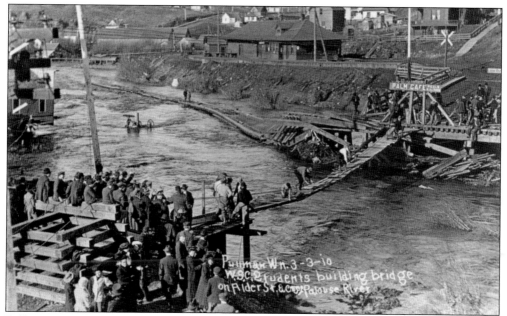

Pullman's 1910 flood washed out all the bridges across the Palouse River, thus isolating College Hill from the rest of the town. Two days later, students from WSC were completing this temporary footbridge at Alder (now Kamiaken) Street. Most were civil engineering students working under the direction of their professor. The Northern Pacific depot in the center of this picture was replaced about 1917 with the building now called the Pufferbelly Depot.

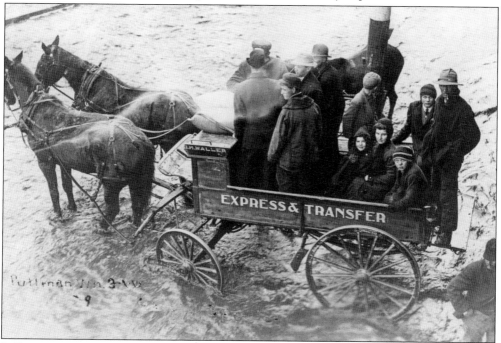

Pullman's worst flood, on March 1, 1910, brought out drayman Isaac H. Waller, who used his cart to ferry people across the downtown streets. Even after the floodwaters receded, much muck, a large amount of debris, and some water remained.

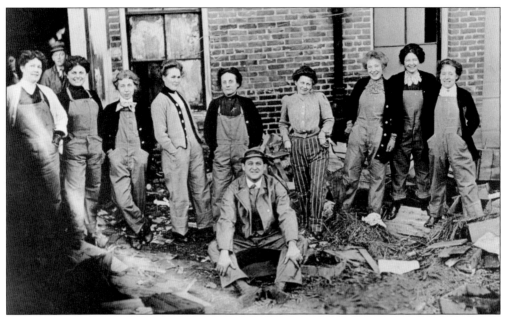

The Burgan-Emerson Mercantile cleanup crew took time to have their picture taken on March 2, 1910, following Pullman's worst flood. J. N. Emerson is seated in front. According to a note written at the time, the women, all employees, were "a little shy about having their pictures taken in overalls." Second from the left is Claudia S. Goss. Fourth and fifth from the left are Amelia Emerson and Bessie Brobst. At the far right is Belle Kincaid.

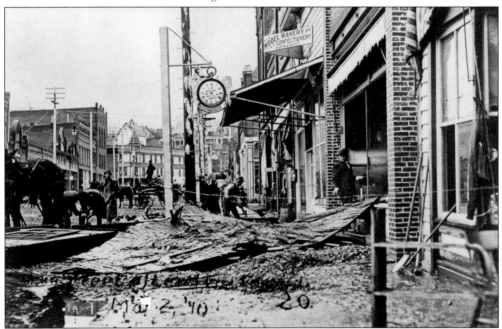

Cleanup from Pullman's most devastating flood began early on March 2, 1910. This view, looking west from 330 Main Street, shows some of the damage and debris left by the flood. Losses from the flood were estimated at more than $2 million. The giant watch hanging in the center of the picture was in front of the Miller Jewelry Store.

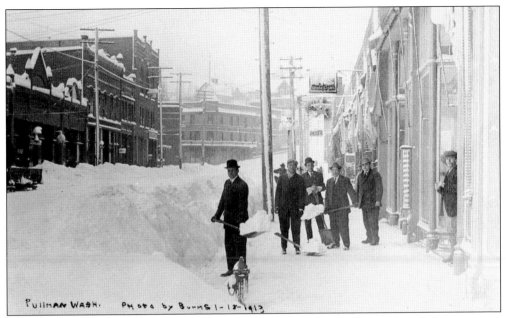

In January 1913, Main Street was buried in so much snow that residents worried about a repeat of the destructive flood of 1910. Fortunately, the snow melted gradually with no flooding. In this picture, the barber pole at right marks Harry Austin's barbershop. The building in the center was the Artesian Hotel at the southwest corner of Main Street and Grand. After a 1922 fire, a brick building replaced the old hotel with an auto dealership.

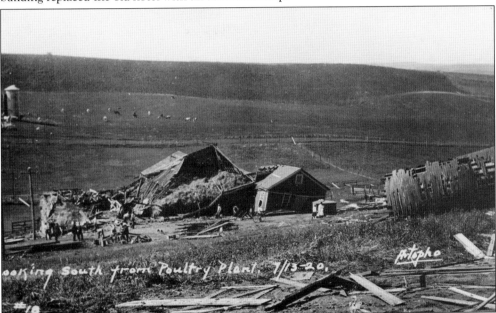

Pullman's only tornado struck July 13, 1920, on the agricultural campus of WSC. Destroyed were the large horse barn, the sheep barn, and several other facilities including a chicken coop. The large stave silo at the right was rolled 200 feet up the hill. The tornado was part of a violent electrical storm that caused considerable damage in the southern part of Whitman County. One of the barns destroyed in the storm was at the site of the present French Administration Building.

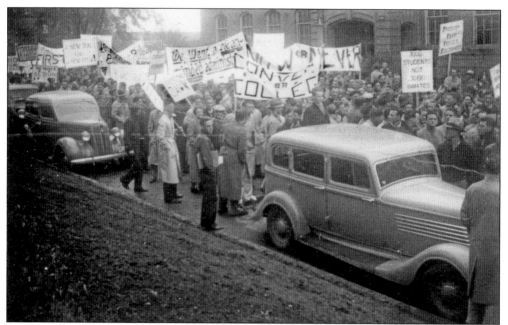

After the eight demands of the Students' Liberty Association were rejected by WSC president Ernest Holland, the SLA held a protest parade on May 5, 1936, as part of a student strike. Led by a 75-piece volunteer band, an estimated 3,000 students marched to the administration building (now Thompson Hall). Marching in front of College Hall, these students carry signs reading, "Convent or College," and "We want a progressive dean of women."

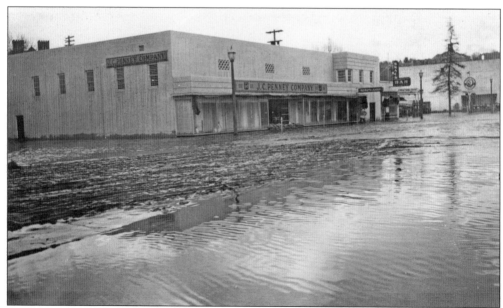

Pullman's flood of 1948 resulted in this East Main Street scene of the JC Penney building, which later housed Ken Vogel Clothing and is now Lily Bee's Consignment Shop. To the right of the building is a beauty shop, the Snack Bar, and Washington Chief Gasoline station.

The Easter Massacre on April 17, 1949, shocked the town. George McIntyre, a World War II veteran described as having a "mercurial temper," murdered four men before he was killed. Early in the afternoon, following nine months of wrangling with local police over a series of traffic tickets and alleged assaults, McIntyre had shot and killed a policeman. Later McIntyre positioned himself on the brush-covered western edge of College Hill overlooking North Grand Avenue and fired hundreds of shots, killing three men and injuring four more. The shooting spree lasted 45 minutes, until authorities brought McIntyre down. One shot struck the windshield of deputy Clarence Davis's car, who later posed in the car for the photograph above. The picture below shows the crowd that gathered around an ambulance by the Northern Pacific Railroad tracks near North Grand Avenue after McIntyre had been killed.

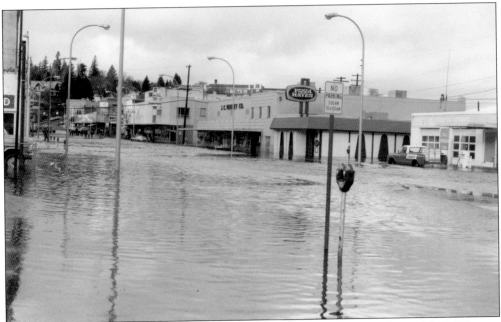

The January 1972 flood in downtown Pullman reached a depth of 4 feet in front of the JC Penney Store at 400 East Main Street, later home to the Ken Vogel Clothing Store. The Neill Furniture Store on the northwest corner of Main and Pine Streets also sustained major flood damage.

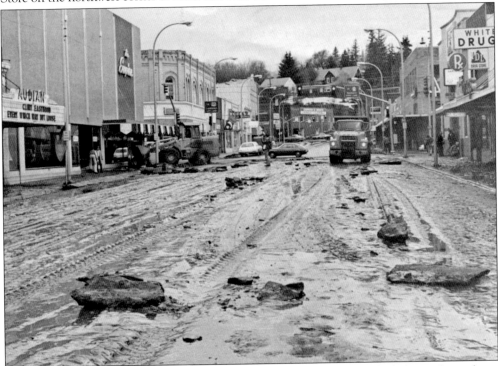

Pullman's 1979 spring flood peaked at three o'clock in the morning. By daylight, as shown here, the waters had subsided, leaving the streets littered with ice blocks and several inches of rich Palouse soil.

This arson fire on April 4, 1970, destroyed a major portion of Rogers Stadium. It came at a time of much unrest on university campuses across America. The Vietnam War was raging, and student protests had come to WSU. The perpetrator of this disaster was never caught. Rogers Stadium has since been replaced by Martin Stadium.

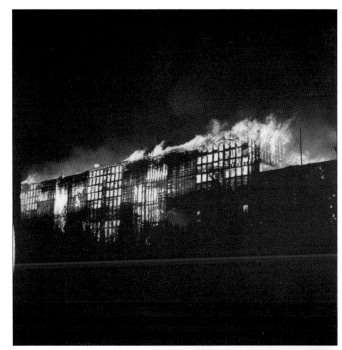

Everyone in Eastern Washington has a Mount St. Helens story. The volcano erupted Sunday, May 18, 1980, and by 3:00 p.m. Pullman had become totally dark and ash began to fall. The next morning when it became light again, Pullman appeared as if under snow. WSU was closed, and the spring semester became totally disrupted as students left Pullman. Don Peters is shown wearing a mask and shoveling ash at his Lamont Street home.

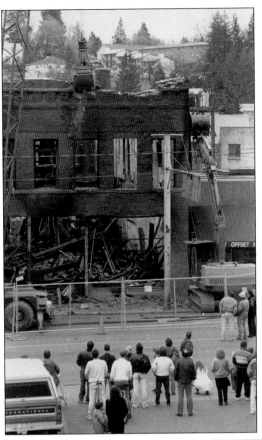

The Bloomfield Block, a historic Pullman landmark at the southeast corner of Grand and Olsen, was destroyed by fire in February 1992. It was replaced at that site by the Cougar Plaza. The Bloomfield Block was built in 1908–1909 by Pullman area farmer George Bloomfield and was initially named the "New Palace Hotel" after Pullman's first hotel. Over the years it housed many businesses ranging from a café to a bus depot to an art gallery.

A spectacular fire destroyed the historic Corner Drug building on October 29, 2000. Originally located on the southeast corner of Main and High Streets, the Corner Drug moved about 1916 to this 1890 building on the southwest corner of Main and Kamiaken Streets. No one was occupying the second floor.

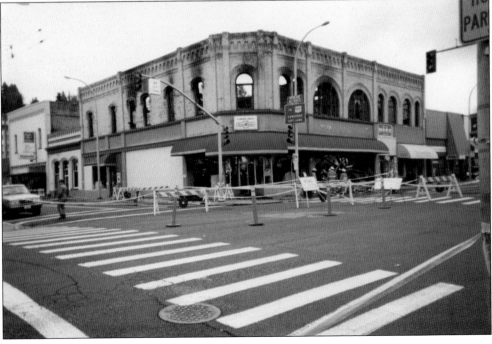

Eight

CELEBRATIONS AND SPECIAL EVENTS

An Eventful Moment.

Former U.S. president William Howard Taft visited the Washington State campus in 1920. During his stay, he awarded a silver trophy cup to the freshman class, winner of the annual Campus Day activity contest. Four "coaches" for victorious freshman teams are shown standing behind Catherine Mathews (Friel), chosen to represent the class. The setting is the dirt hillside south of the football field. She says there was much confusion. Athletic director "Doc" Bohler admitted he had forgotten to order the trophy. In desperation, he told a male student, "Run up to the Agriculture Building, and take a silver cup out of the trophy case, and we will use it." Neither the president nor Catherine knew what was inscribed on the substitute cup. Taft asked her why the trophy was being awarded. She explained that the freshman girls' team had been victorious in the class competition. Taft started to read the wording on the trophy, looked at the recipient, and kept shaking his head in puzzlement. The cup was inscribed, "Prize Bull Segus Pontiac Acme."

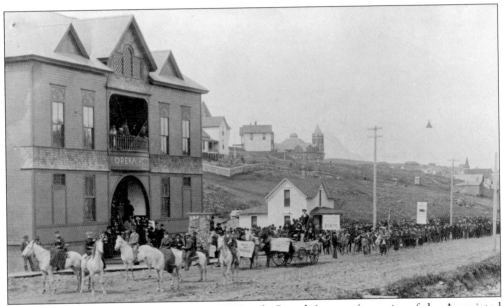

The Pullman Opera House, located at 405 South Grand Avenue (now site of the Associated Brokers), was built in 1893 for $15,000 on subscriptions from businessmen. When hard times prevented many from fulfilling their pledges, George Ford purchased it at a tax sale for $1,500. His Pullman Auditorium was the scene of many presentations such as this one after a May 25, 1898, veterans' parade. It was destroyed by fire on June 14, 1910.

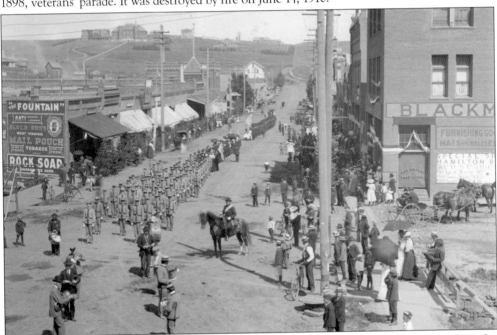

Marchers in May 1898 turn the corner at Main Street and Grand Avenue. The occasion was a three-day encampment of the GAR (Grand Army of the Republic), Union veterans of the Civil War. They, followed by WSC cadets, were on their way from Reaney Park to the Pullman Opera House on South Grand Avenue to hear a lecture about Cuba and the Spanish-American War. In the foreground on a horse is K. P. Allen, a veteran of the Civil War who was later Pullman's first full-time postmaster (1902–1914).

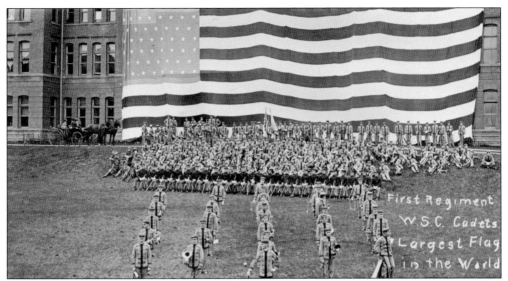

In 1909, the largest American flag in the world was made in Pullman by Pauline Mitchell, wife of Capt. Harry E. Mitchell, military instructor at WSC, for decoration at the annual military ball on February 22. Measuring 110 by 39 feet, it was made of ordinary bunting and contained a mile of stitching. It is displayed here on the west side of the science building (now Murrow Communications Center). The flag flew that summer at Seattle's Alaska-Yukon-Pacific Exposition atop a 170-foot pole.

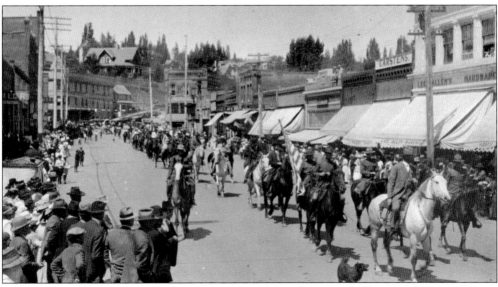

The Pioneer Parade in June 1918 was no ordinary parade. It depicted 14 epochs in Whitman County's history, beginning with Steptoe's defeat in 1858. More than 3,000 people lined the streets to watch. Parade entries ranged from immigrant wagons to mule trains to quadrille dancers. Realism was added when a band of "mounted desperadoes" rushed through the streets and held up a stagecoach. After the parade, the annual Whitman County Pioneer Picnic was held in the city park.

King Prince Allen, otherwise known as K. P. Allen, was a Union veteran of the Civil War, who proudly wore his uniform for patriotic celebrations and other community events. The Allen family played an important role in Pullman's development during its early years. The photograph is undated, but it appears to be from the late 19th or early 20th century.

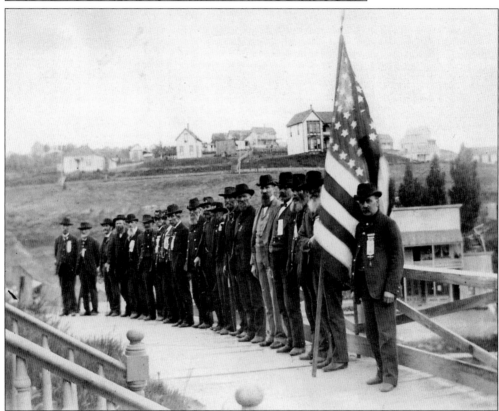

In 1910, GAR members pose for this photograph on the boardwalk before the Congregational Church, which stood on the southeast corner of Paradise and High Streets. Among the veterans are Pullman pioneers King Prince Allen, Levi Crawford, and Edwin Laney. Behind the flag, on Sunnyside Hill, is Dr. H. J. Webb's residence and hospital, and at the right is a photography studio on Grand Avenue.

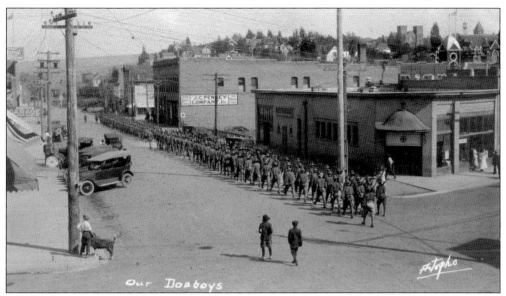

In 1918, Companies A, B, and C of the U.S. Army Training Battalion at WSC are marching north on Grand Avenue. They were signal corps units learning radio communications. Their training took place in an unfinished campus building, now Carpenter Hall. Enlisted men at that time were nicknamed "doughboys." One young recruit, proud of what his group had learned in a very short time, wrote on the back of this photograph, "Note the straight lines."

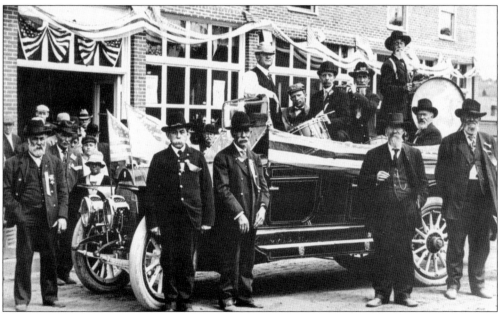

Civil War veterans gather for this photograph in June 1912, during the annual encampment for the State of Washington GAR. These old comrades are standing in front of the Martin Garage, located on the west side of North Grand Avenue—approximately where the Cordova Theater (now the Pullman Foursquare Church) now stands. The bearded man on the left is K. P. Allen, Pullman postmaster.

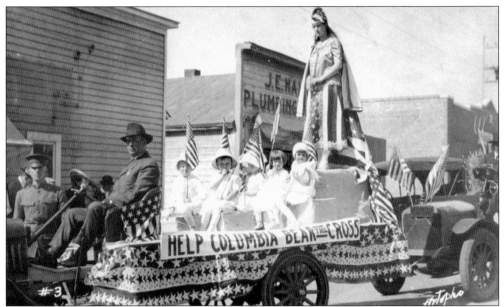

Pullman celebrated the end of World War I on November 11, 1918, with a giant parade. Although news of the Armistice ending the "War to End Wars" had reached Pullman in the middle of the night, volunteers quickly organized a grand parade for the morning featuring a band, 22 platoons of soldiers in training at the college, many floats, and other marchers. This picture was taken on North Grand Avenue. The brick building on the right was the Pullman Laundry, which was built in 1917.

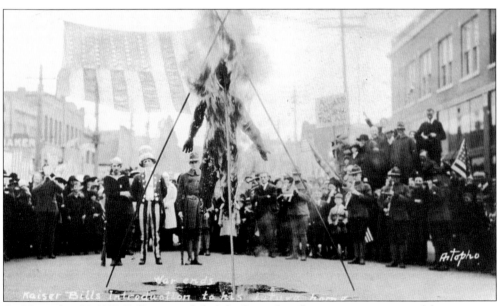

On November 11, 1918, Pullmanites defied the Spanish influenza quarantine to celebrate victory over Germany and the end of World War I with a big parade. It culminated at Main Street with the burning of Kaiser Wilhelm's effigy as the band played "The Star-Spangled Banner."

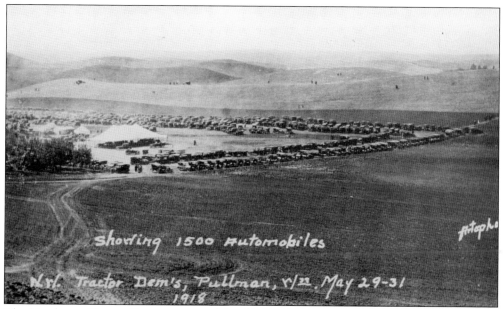

Showing 1500 Automobiles

Nw. Tractor Dem's, Pullman, W/2, May 29-31 1918

The Northwest Tractor Demonstration, May 29–31, 1918, attracted over 10,000 people. It was held at the farm of Arthur Cole, 2 miles west of Pullman, and it featured more than 50 kinds of tractors. Cultivators, trucks, automobiles, and other types of farm machinery were displayed in addition to tractors.

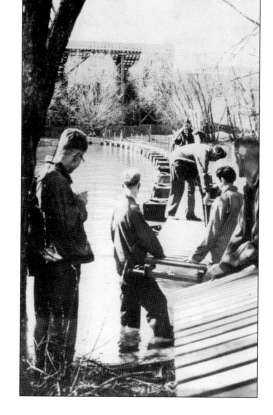

In the spring of 1927, ROTC students at WSC constructed a Lampert-type pontoon bridge across Silver Lake. Holding the stopwatch is R. A. Glaze. After completing the bridge, the cadets threw their officers into the cold waters of the lake, which was popularly known as "Lake de Puddle." Silver Lake was located at the present site of Hollingbery Fieldhouse and Mooberry Track.

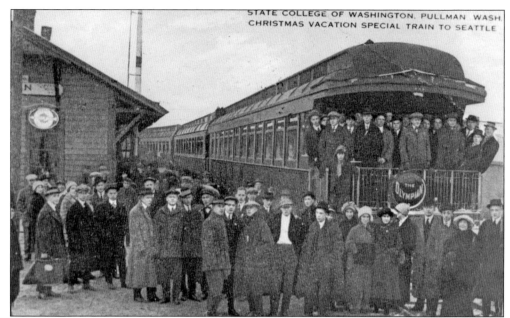

STATE COLLEGE OF WASHINGTON, PULLMAN WASH.
CHRISTMAS VACATION SPECIAL TRAIN TO SEATTLE

The "Christmas Vacation Special" was photographed just before its 4:00 p.m. departure from Pullman's Oregon-Washington Railroad depot for Seattle and Tacoma on December 20, 1916. Until the late 1950s, most students came to campus by rail. This train promised that Trimble's Orchestra would play "for the dances," and that "everything would be done for the comfort and entertainment of the party." The wooden depot was replaced in 1940 by a brick Union Pacific depot, now the WSU Visitor Center.

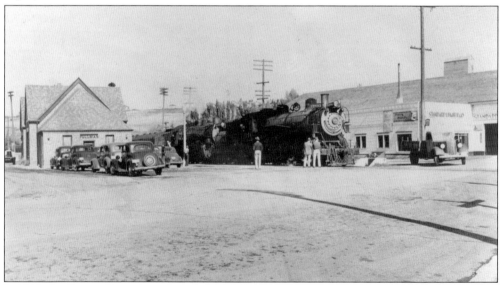

In 1940, the Cougar Special stands at the new UP station, ready to take vacationing WSC students to western Washington. Both the Union Pacific and Northern Pacific ran specials for Christmas and spring vacations. Leaving Pullman at 5:00 p.m. on Friday, they would reach Seattle at 8:00 a.m. Saturday. Ten days later, the returning train reached Pullman at 7:00 a.m., enabling sleepy students to attend their 8:00 a.m. Monday classes. Round-trip coach fair to Seattle was $10.30; fare for a sleeper berth was $13.40.

In June 1937, the First National Bank of Pullman celebrated the 50th anniversary of its founding with period costumes and floral displays. After moving across Main Street in 1917, the bank was located on the northwest corner of Main and Kamiaken Streets, now Design West. In 1964, the bank merged with Old National Bank, which in 1988 was absorbed by U.S. Bankcorp. In 1993, it moved to the southeast corner of Main and Kamiaken Streets.

Abraham Lincoln's birthday was celebrated in 1932 by WSC students, who built an 8-foot snow statue of the 16th president. Using table knives, Paul Cramer, a senior in chemical engineering, and Milford Schultz, a senior in education, sculpted the statue from a large snowball on Campus Street. Neither student had ever studied art. Local photographer R. R. Hutchison forwarded a film of the statue to be used in newsreels around the country. Pullman experienced near-record snowfalls that winter.

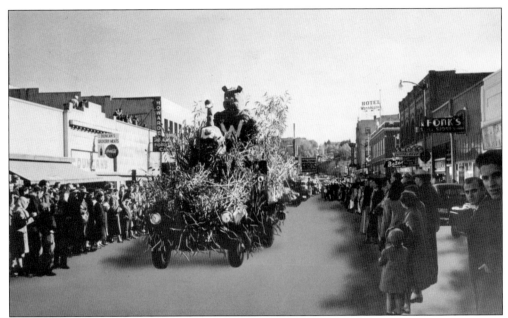

The WSC Homecoming Parade down Pullman's Main Street on October 27, 1951, was cheered on by more than 10,000 viewers. It featured 80-plus entries ranging from an antique steam locomotive to a multi-legged dragon as well as the usual floats and marching bands. The parade inspired the Cougars to trounce Oregon by a score of 41–6 that afternoon.

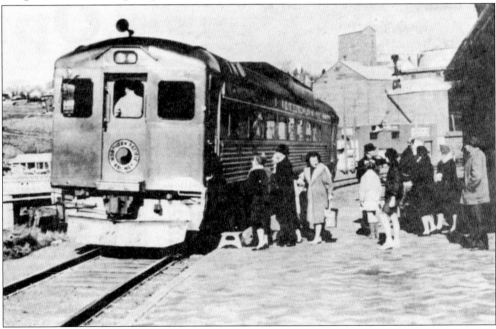

Pullman rail service made its final run on February 28, 1966, with this Budd RDC (Rail Diesel Car), nicknamed the "Bug." Here it is in front of the Burlington Northern depot in Pullman (now the DRA Real Estate offices), loading passengers for its final run. The Pullman City Council supported the idea of continuing rail service to Spokane; a "Save the Bug" committee was organized to try to save passenger service, but to no avail.

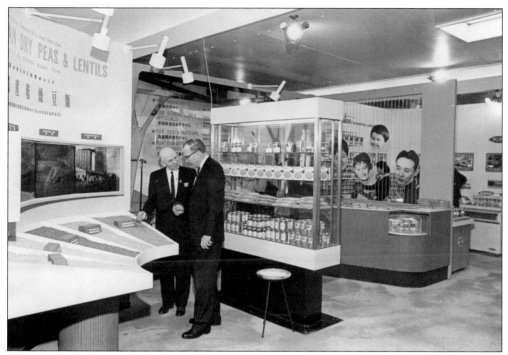

Lentils from the Palouse arrived in Japan in April 1965 and were displayed in the Washington State Pavilion at the Tokyo Trade Fair. Bringing the legumes were Ed Dumas, owner of Dumas Seed Company of Pullman and Moscow, and Wayne Chastain, manager of the Inland Empire Pea Growers Association. The marketing venture was reported to be a great success.

The Lawson Gardens, on Pioneer Hill, were dedicated in a ceremony held on June 10, 1987. Gerald Lawson, Pullman area farmer, endowed a $1 million trust fund to construct and maintain the gardens in memory of his first wife. The Gardens, located south of Kruegel Park, were a longtime dream of Lawson, who envisioned them as a place where people could escape day-to-day cares and enjoy quiet times in an atmosphere of beauty.

The appearance of North Grand Avenue was much improved in the first decade of the 21st century by the efforts of the North Grand Greenway Committee. On March 22, 2006, the WSU Presidents Grove was dedicated. The grove was begun with trees provided by the four living presidents of Washington State University. On the right in this picture of the dedication are Karen Kiessling and Mary Jo Rawlins. On the left are six recent mayors of Pullman.

This lentil lover stirs the 600-plus gallons of lentil chili that are given away to the first few hundred attendees at the National Lentil Festival. The annual festival held in August is the capstone community event that has drawn people from across the Pacific Northwest since 1989. The weekend activities include the Legendary Lentil Cook-off, parade, live music, and children's activities, all free to the public.

Nine

Community Activities and Everyday Life

In 1942, Pullman's "Tractorette School" was the first in the state to teach young women how to run tractors. This enabled them to replace men entering the armed forces for World War II. When the students drove their tractors on the Washington State College campus after three weeks of instruction, newsreel cameramen from Paramount, Pathé, and MGM were on hand to film the event. An estimated 50-million movie fans in theaters across the country saw the local girls parading their skills.

William H. Tapp was one of three rural mail carriers for the Pullman area in 1902. Their trips started and ended at one of Pullman's livery stables, as shown here. Tapp's 25-mile route led up Union Flat Creek, over the hills to Chambers and Busby, and finally back to Pullman. When the roads were bad, the trip took two days, with an overnight stop somewhere along the route.

Dr. William L. White strolls down Main Street with his year-old daughter Gracia in 1898. The broad wooden sidewalk helped keep pedestrians out of the mud. White practiced medicine in Pullman for 18 years and was also associated with brothers Archie and Charles in the White Drug Store. In the distance at left is Pullman's third school, the 1892 building. It is the site of the present-day Gladish Community Center.

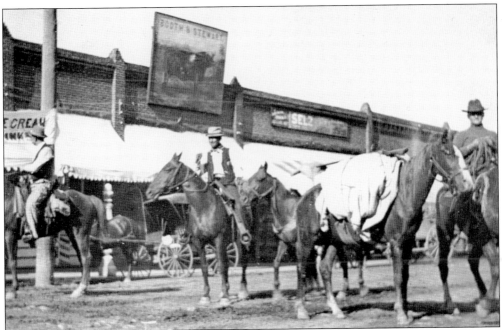

Men of Pullman prepare for a camping trip about 1893. The man on the right, John W. Mathews, was prosecuting attorney in the late 1890s and was elected mayor in 1916. His grandson, Wallis W. Friel, also made a career of the law. The buildings in the background are still standing, although much modified, on the north side of the 200 block of East Main Street. At that time, they housed an ice cream parlor and the Booth and Stewart Meat Market.

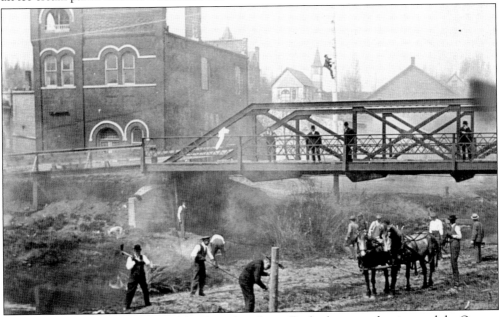

A crew of volunteers works east of the Kamiaken Street Bridge between the river and the Oregon Railroad and Navigation tracks during the Pullman Chamber of Commerce spring cleanup in 1911. The bridge, erected just after the 1910 flood, was replaced in the 1920s by the present concrete bridge. The old Pullman City Hall can be seen to the left of the bridge.

A threshing crew near Pullman takes time out in 1913 to pose for the photographer. In this operation, straw was used as fuel to drive the engine, which in turn was connected to the thresher by a long belt. Part of the belt is visible behind the man on the left. The water tank is at the far left.

A ditch-digging crew, preparing for the installation of city water mains, took time to put down their pickaxes and pose for this picture in 1914. The contract for major improvements to Pullman's water system had been awarded in late April to Hughes and Company of Spokane. By the end of May, new 10-inch mains were being placed in the ditches, starting from the well near 315 North Grand Avenue and proceeding south.

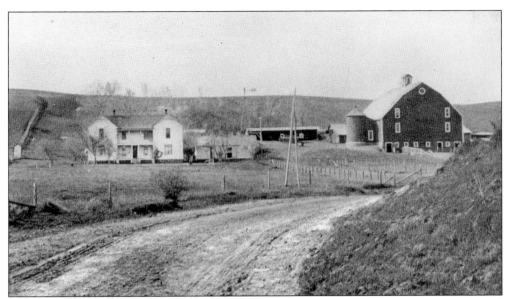

"J. H. Weeks Dairy Ranch 1 mile south of Pullman" was the caption for this picture in a 1911 booklet extolling the town. Milk then sold for 8.5¢ per quart delivered in Pullman, and each of the 25 cows in Weeks's herd returned an average of $13 per month. The booklet was originally published by the Oregon-Washington Railroad and Navigation Company, which eventually became part of the Union Pacific Railroad.

A dog-powered washing machine operated briefly in the 1930s at the Weeks Dairy Farm. The farm was located on the east side of Highway 27, now South Grand Avenue, just south of what is now the Wheatland Shopping Center. Sarah Weeks, standing at the right of the picture, explained, "The dog ran the treadmill to run the washing machine, but on wash day he ran to hide."

Snow towers above the sidewalk on Main Street in January 1913. Just left of center is the Artesian Hotel, at the corner of Main Street and Grand Avenue. The home of J. M. Palmerton, an early pioneer of Whitman County and Pullman businessman, can be seen above the hotel. This home still stands at the corner of Main and State Streets. The tall brick building to the right, which still stands, was the Neill Furniture Store.

Frederick D. Gelwick and his roasted peanut wagon were a familiar sight on the streets of downtown Pullman in 1915. This picture appears to have been taken near the northwest corner of Main and Pine Streets. In the early years of the 19th century, Gelwick had been a policeman and night watchman in Pullman. He was also noted in 1901 for growing a parsnip that measured 4 feet, 7 inches long.

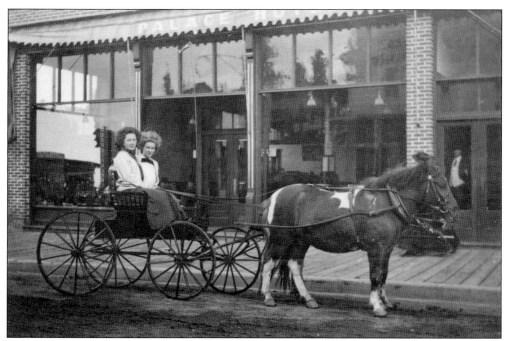

A pony cart on North Grand Avenue is pulled by one of Enoch A. Bryan's Shetland ponies in 1911. Bryan was president of WSC from 1893 to 1915. The two passengers are his daughter Lila and her friend Juanita Strong. The building in the background is the Bloomfield Block, then the New Palace Hotel and later the Pullman Hotel. It burned down on February 2, 1992. The Cougar Plaza now occupies the space.

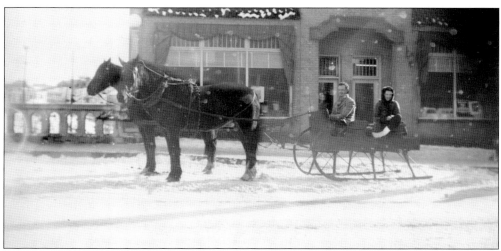

This repaired historic cutter was used during gas rationing between 1942 and 1945. It stands in front of the Hutchison Photographic Studio at 200 Northeast Kamiaken Street, now Swilly's Restaurant. The cutter had been used by the postal service for carrying the mail in the 1880s, but it was badly damaged later in an accident. Riding in the cutter are Irene Wiggins and her son. The Kamiaken Street Bridge over the Palouse River can be seen on the left.

The Pullman CCC boys in the 1930s were stationed at a camp on the present-day site of the Pullman-Moscow Airport. The CCC (Civilian Conservation Corps) was a Depression-era federal program enacted in 1933 to give employment to young men by enlisting them to fight soil erosion and to undertake other conservation projects. It was one of several measures enacted by the Roosevelt administration to provide relief during the Depression.

The Civilian Conservation Corps camp at the Pullman Airport was established in 1935. The young men lived in a disciplined, military-style setting and worked on projects useful to the local area. Here the purpose was to stop erosion, plant trees, repair gullies, and prevent fire hazards. The camp lasted until 1937. Some of the trees they planted can still be seen on the west side of U.S. Highway 195 between Pullman and Colfax.

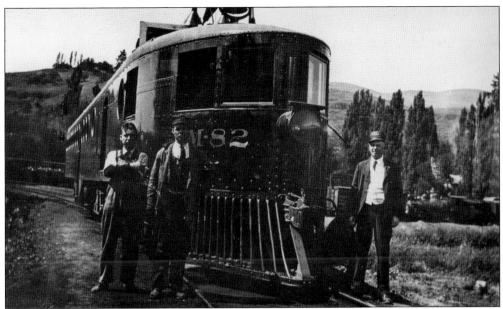

The self-propelled Union Pacific Railroad "Bug," seen in this 1919 photograph, carried passengers on the Colfax-Pullman-Moscow run from 1917 to the mid-1930s, when it gave way to steam locomotives. It was operated by the Oregon-Washington Railroad and Navigation Company and could carry about 70 passengers. Dating from 1908, such vehicles were called McKeen cars, after their inventor, but they were also nicknamed "doodle bugs," later shortened to "bugs."

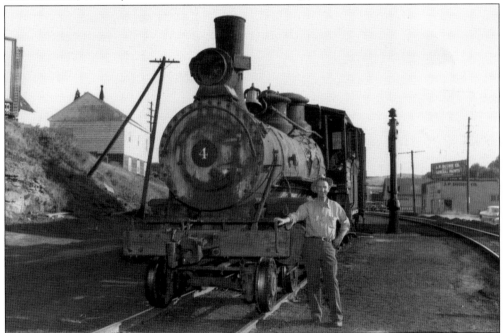

Steam locomotives were a common sight in Pullman for many years. This one was on the Northern Pacific Railroad tracks next to Grand Avenue just north of Whitman Street. The photograph is undated, but it appears to be from the 1940s. The man next to the engine is the late Axel Melander, who served as Pullman fire chief and was a Washington Water and Power foreman.

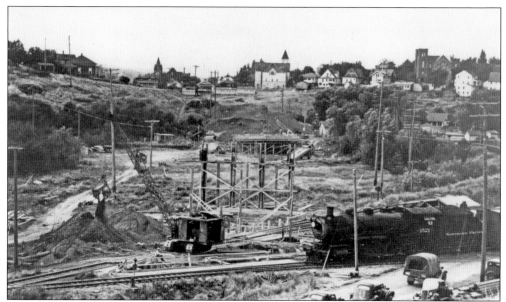

Construction on the viaduct connecting Main Street with the Moscow Highway began in 1938. The cost was about $275,000. In this picture, looking west, the Greystone Church is the third building from the top right. The viaduct was dedicated in June 1939 with a gala ceremony that included a speech by Lacey V. Murrow, director of the Washington State Department of Highways. At the time, Lacey Murrow was better known than his younger brother, Edward R. Murrow.

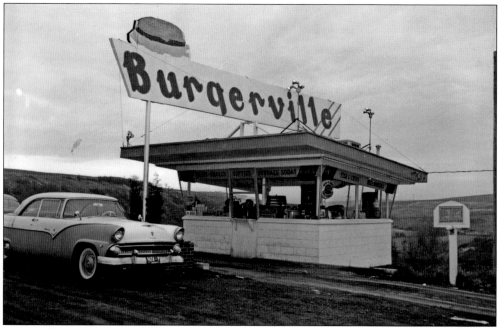

Burgerville Drive-In, in this 1958 photograph, was the unofficial gateway to the west side of Pullman from 1954 to 1975. Rumor has it that first-time visitors occasionally mistook its sign for the town's name and drove on to Moscow before realizing their mistake. Located on Davis Way, the building was remodeled and reopened in 1995 as the first of several Daily Grind Espresso Drive-Thrus in the area. It was razed in 2009.

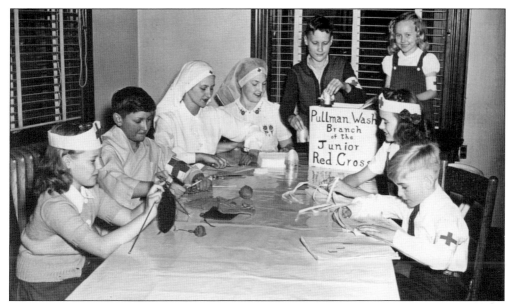

The Junior Red Cross, Pullman Branch, was busy in 1945 with a number of tasks. Pictured here from left to right are the representatives from Pullman's schools: Edison School's Elaine Yoder and DeWayne Allert; Pullman High School's Henrietta Allert and Helen Bendixen; Franklin School's Richard Prouty and Sharon McGinnis; and Lincoln Junior High's Nancy Graham and Peter Botting.

The Wapomeo Campfire Girls of Pullman posed for this picture about 1940 with each girl wearing a ceremonial gown she had made and beaded herself. In the first row, from left to right, were Laura Lee Thompson, Patsy Livingstone, and Ellen Heflebower. In the second row were Marion Glover, Henrietta Allert, Barbara Crabtree, Shirley Phelps, Virginia Shelton, and Helen Bendixen. Their leader was Ruth Bendixen.

In the late 1960s, businesses along Grand Avenue were expanding southward along Highway 195. This photograph from about 1970 shows the Leisure Lanes Bowling Alley in the center and Sunnyhill Mobile Homes at the far right.

These Kiwanians are prepared to bring on the pancakes in December 1977. Seen here decked out to cook at the pancake feed are, from left to right, Leonard Young, Phil Keene, Al Russell, Ben Bendixen, Oscar Loreen, Harry Weller, Howard Hughes, and William Crawford. The annual Kiwanis Pancake Breakfast celebrated its 50th anniversary in December 2009.

This picture shows the Pullman City Playfield as it appeared in 1978. The low buildings on the hillside were the Thunderbird Motel and Restaurant. Above are the WSU dormitories. From left to right, they are Stephenson North, Rogers, Stephenson East, and Stephenson South. At the base of the hill, in the valley, was the old road to Moscow. It had become the east side's service area, with such businesses as Pratt Mayflower and the Down Under Restaurant.

A check dam was constructed in 1984 on the South Fork of the Palouse River near Reaney Park. This was a project of the Pullman Civic Trust under the leadership of Loretta Anawalt. Architect Don Heil designed the dam to create a small reservoir and waterfall for visual enjoyment. In the background is the Spring Street Bridge.

Don Rodgers and Butch, the WSU mascot, celebrate the dedication of the SR 270/Cougar Bridge construction on July 25, 1996. This $7 million, two-year project completely rebuilt the Main Street Viaduct over the railroad, street, and Palouse River. The original bridge was built in 1939 for $275,000 with four cougar statues. Spokane sculptor Rodgers successfully rejuvenated the four weathered statues, giving them a new, more streamlined form.

On April 11, 1988, Pullman celebrated the centennial of its incorporation with many activities, including the dedication of the fountain located near the intersection of Olsen and Kamiaken Streets. On the right is Pullman historian Esther Pond Smith, at whose suggestion the fountain was designed and constructed. Pullman in its early days was known as the "Artesian City" because of its many artesian wells, one of which was the model for this replica.

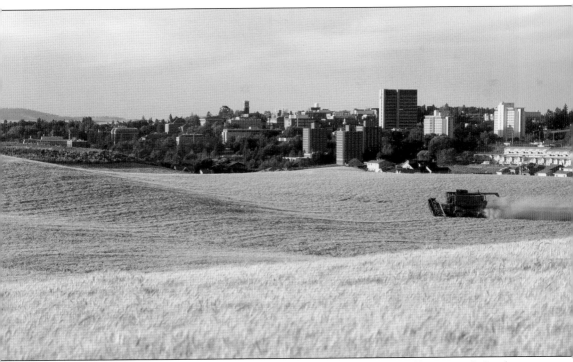

This photograph of a modern wheat harvest on the Palouse surrounding Pullman concludes this visual trip through the city's rich history and the special events and people that shaped its destiny. It is fitting to end with this agricultural scene showing continuing use of the rich farmlands that drew the earliest settlers to Pullman. The arrival of the Bowlin Farr family in 1874 and the subsequent settlement of other farmers, ranchers, and merchants led to the founding of Pullman. All had a special vision of the promise of the region. Very few were disappointed. While the mechanized farming methods of today would amaze the first pioneers, the beauty of the region's rolling hills that they so loved still enchants today's residents and visitors.

www.arcadiapublishing.com

Discover books about the town where you grew up, the cities where your friends and families live, the town where your parents met, or even that retirement spot you've been dreaming about. Our Web site provides history lovers with exclusive deals, advanced notification about new titles, e-mail alerts of author events, and much more.

MADE IN THE USA

Arcadia Publishing, the leading local history publisher in the United States, is committed to making history accessible and meaningful through publishing books that celebrate and preserve the heritage of America's people and places. Consistent with our mission to preserve history on a local level, this book was printed in South Carolina on American-made paper and manufactured entirely in the United States.

This book carries the accredited Forest Stewardship Council (FSC) label and is printed on 100 percent FSC-certified paper. Products carrying the FSC label are independently certified to assure consumers that they come from forests that are managed to meet the social, economic, and ecological needs of present and future generations.

FSC
Mixed Sources
Product group from well-managed
forests and other controlled sources

Cert no. SW-COC-001530
www.fsc.org
© 1996 Forest Stewardship Council

Find Your Place in History.